A Bit of Brundage

The Illustration Art of Frances Brundage

Sarah Steier &
Donna Braun

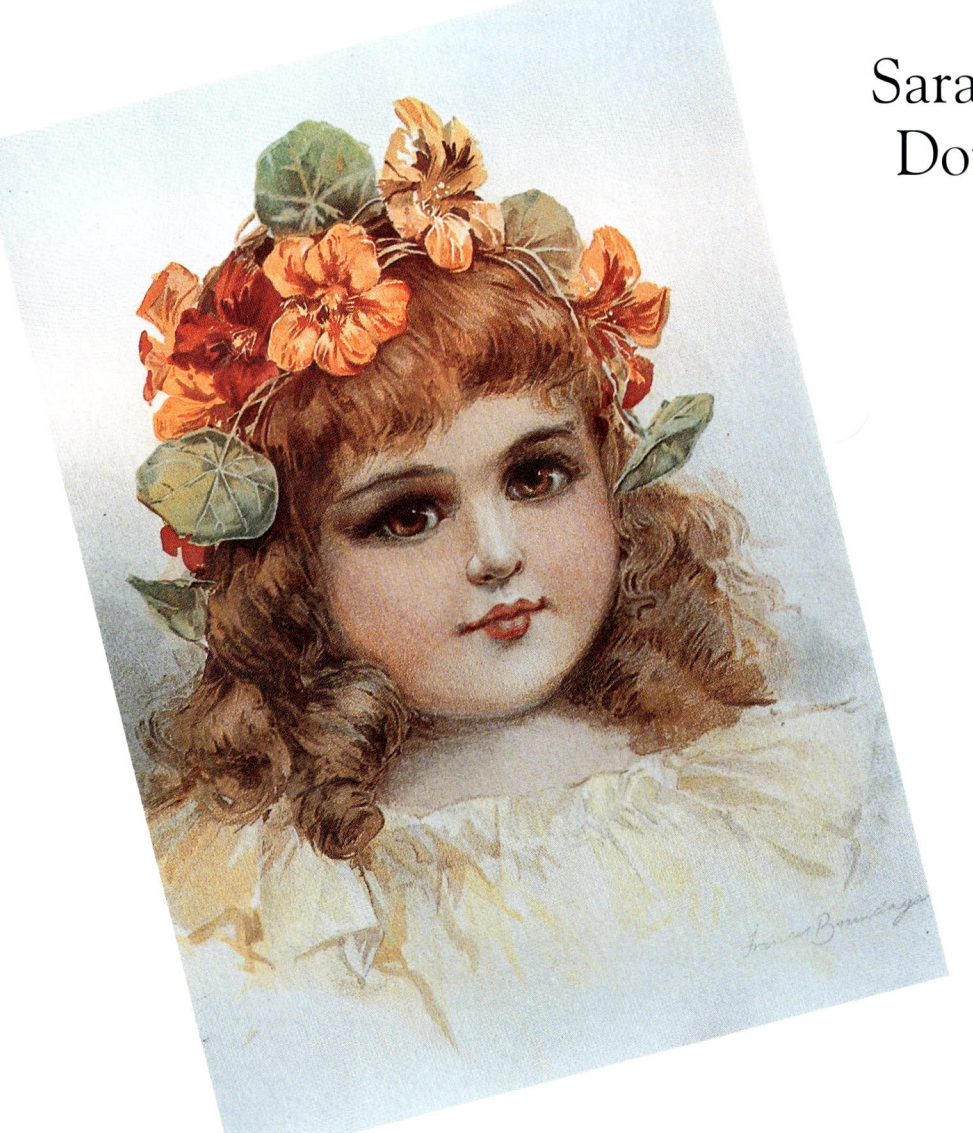

4880 Lower Valley Road, Atglen, PA 19310 USA

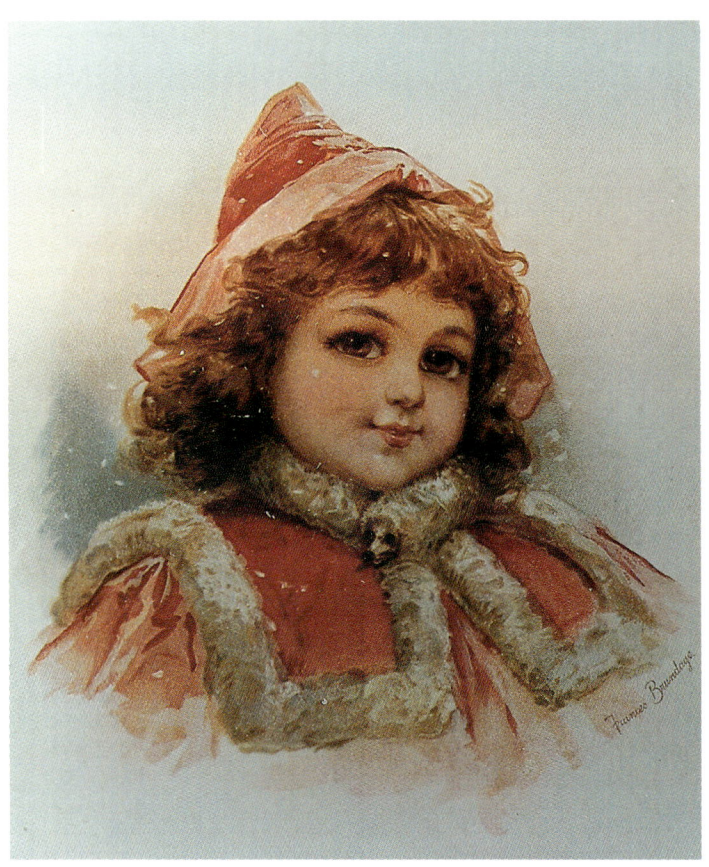

Acknowledgments

The authors wish to thank the following individuals and organizations for supplemental art copies and assistance:

>Jean Beiermeister
>Diane and Ralph Hellebuyck
>Judy Hill
>Kay Jamen
>Marvin Mitchell
>Madalaine Selfridge
>Balliol Corporation
>Old Print Factory

In addition we also want to thank the following individuals for their support and assistance:

>Marie Grainger
>Sheila Larson
>Kalleen Mortensen
>Joanne Pickering
>Betty Snodgrass

And special thanks to our husbands: William Steier and Raymond Braun.

Library of Congress Cataloging-in-Publication Data

Steier, Sarah.
 A bit of Brundage/Sarah Steier & Donna Braun.
 p. cm.
 Includes bibliographical references and index.
 ISBN 0-7643-0716-9 (hardcover)
 1. Brundage, Frances, 1854-1937--Catalogs. I. Braun, Donna. 1922- . II. Title.
NC975.5.B747A4 1999
741.6'83'092--dc21 98-48662
 CIP

Copyright © 1999 by Sarah Steier & Donna Braun

All rights reserved. No part of this work may be reproduced or used in any form or by any means—graphic, electronic, or mechanical, including photocopying or information storage and retrieval systems—without written permission from the copyright holder.
"Schiffer," "Schiffer Publishing Ltd. & Design," and the "Design of pen and ink well" are registered trademarks of Schiffer Publishing Ltd.

Designed by "Sue"
Type set in ZapfcalligrBT/Goudy oist BT/Humanist 521 BT

ISBN: 0-7643-0716-9
Printed in China
1 2 3 4

Published by Schiffer Publishing Ltd.
4880 Lower Valley Road
Atglen, PA 19310
Phone: (610) 593-1777; Fax: (610) 593-2002
E-mail: Schifferbk@aol.com
Please visit our web site catalog at **www.schifferbooks.com**

This book may be purchased from the publisher.
Include $3.95 for shipping.
Please try your bookstore first.
We are interested in hearing from authors
with book ideas on related subjects.
You may write for a free catalog.

In Europe, Schiffer books are distributed by
Bushwood Books
6 Marksbury Rd.
Kew Gardens
Surrey TW9 4JF England
Phone: 44 (0)181 392-8585; Fax: 44 (0)181 392-9876
E-mail: Bushwd@aol.com

Contents

Introduction .. 5

Chapter 1. Books .. 6
Chapter 2. Trade Cards .. 42
Chapter 3. Valentines .. 58
Chapter 4. Postcards .. 84
Chapter 5. Cloth and Paper Dolls 107
Chapter 6. Prints ... 113
Chapter 7. Miscellaneous ... 128
Chapter 8. Calendars .. 143
Book List 167
Bibliography 174
Index .. 175

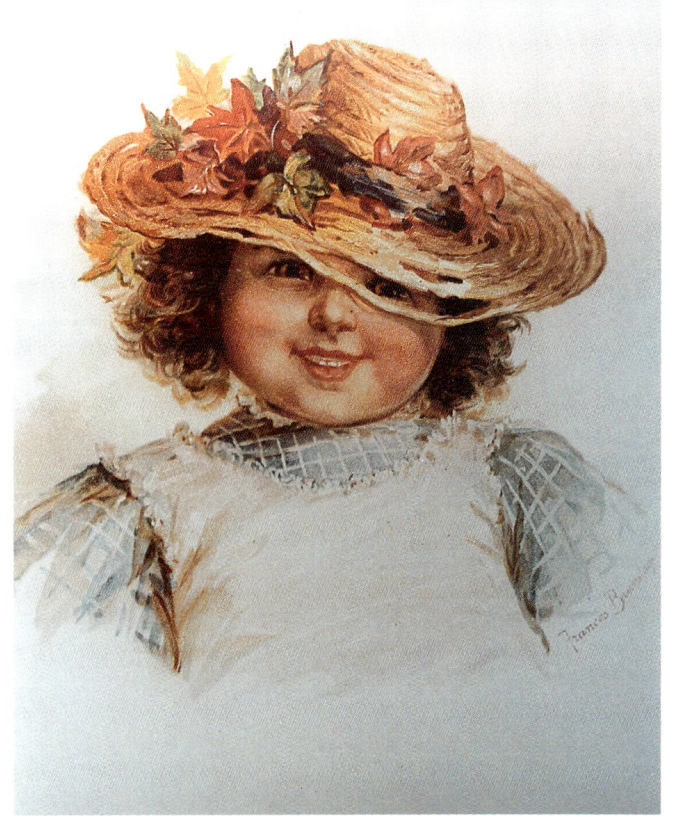

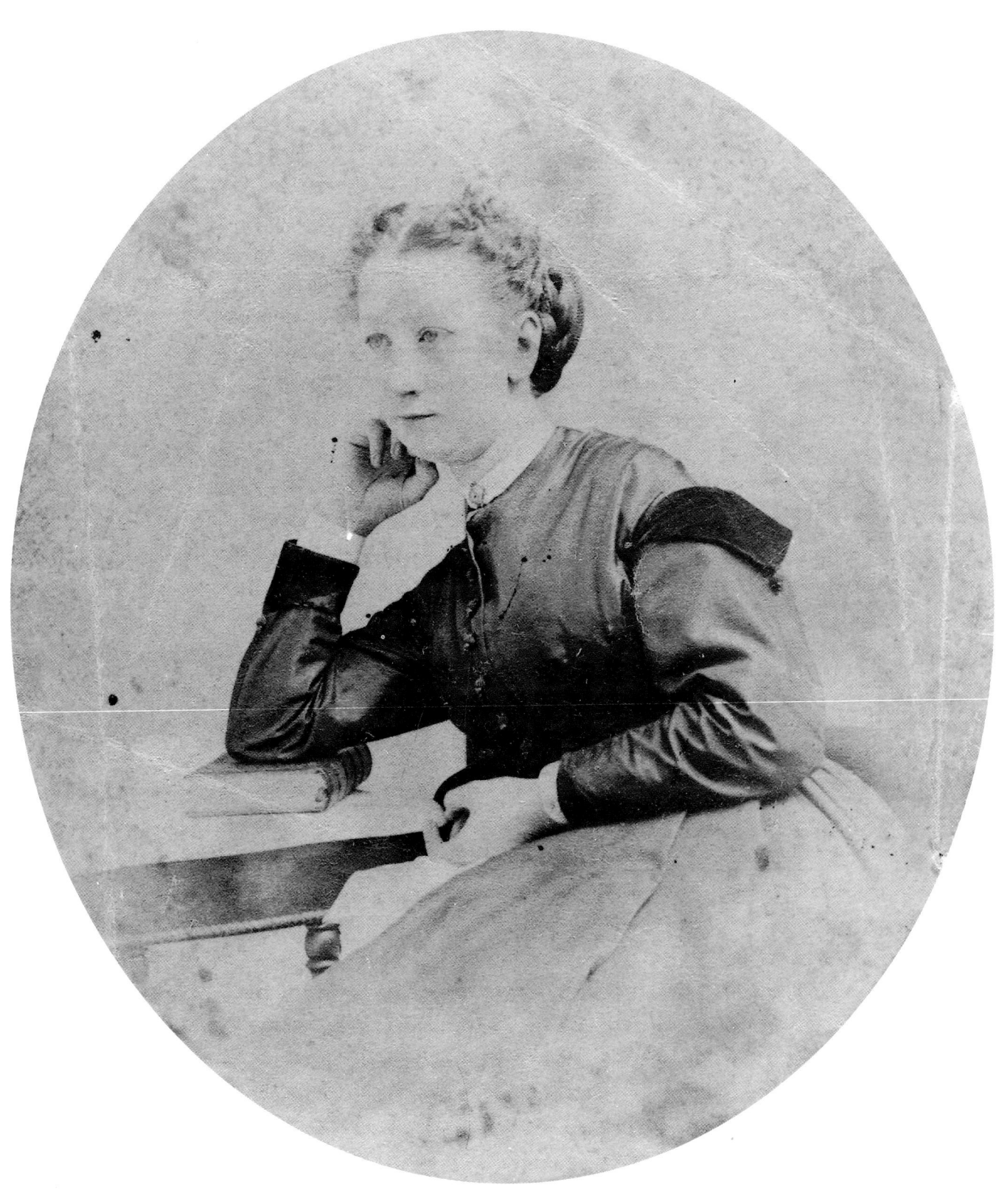

Frances Brundage (1854-1937)
Above picture courtesy of Archives of
American Art, Smithsonian Institution.

Introduction

Frances Brundage (1854 to 1937) was one of the most prolific of the major American illustrators. She was a highly respected artist in her own time, and her style is easily recognized in her portrayal of adorable children, especially in their large and beautiful eyes.

During her 65-year career, she illustrated many more than the 244 books represented here on our book list. Most of the books she illustrated are children's books. Many have color plates of beautiful children, and these books are highly collectible. In addition, she illustrated calendars, trade cards, postcards, prints, valentines, paper dolls, and cloth dolls. Her work can also be seen in miscellaneous items, such as greeting cards, covers of albums, jewelry boxes, fans, die-cuts, paper ornaments, advertisements, painted plates, fans, and bookmarkers.

Frances Isabelle Brundage (née Lockwood) was born in Newark, New Jersey, on June 28, 1854, to Rembrandt Lockwood and Sarah Ursula Lockwood (née Despeaux). She had a sister, Helen Maria Colburn, who became a portrait painter, and a brother, Fred Lockwood. In 1886, Frances married William Tyson Brundage (1849 to 1923), an artist specializing in marine subjects. Their only child was Mary Frances Brundage, who died at the age of 17 months in 1891.

Frances Brundage was trained by her father, Rembrandt Lockwood, an artist who painted church murals and who also was a portraitist, miniaturist, architect, and wood engraver. He disappeared when she was only 17 years old, which forced her, at an early age, to begin earning a living with her art.

Her professional career began when she sold a sketch illustrating a Louisa May Alcott poem to the author, which launched her own career as a book illustrator. The majority of her work was done for the publishing houses of Raphael Tuck & Sons, Samuel Gabriel & Sons, and Saalfield. In the late nineteenth century, she started to work for Raphael Tuck & Sons, a publishing company in England. It was during this period that she did some of her most collectible work, painting beautiful Victorian children. In 1910 she started with Samuel Gabriel Company of New York City. In that period, her art style was more Americana, depicting children at play. She later worked for Saalfield of Akron, Ohio, until the 1930s. Her work was also published to a lesser degree by several other publishing companies including: Stecher Lithographic Co.; DeWolfe, Fiske & Co.; Fred Stokes; Charles E. Graham & Co.; E. P. Dutton; and Hayes Co.

Frances collaborated with her husband, William, on some projects. One of their best was the book *The Story of Columbus*, published in 1892 by Raphael Tuck.

Brundage is especially known for her portrayal of beautiful Victorian children. One of her specialties was illustrating ethnic children. These children from diverse cultural backgrounds appeared in many of her paper dolls, books, valentines, trade cards, die-cuts, postcards, and prints. She excelled in her humorous images of children and adults.

Brundage's signatures on her illustrations were usually either a monogram of her initials or a full signature in script or in print. She also illustrated jointly with her husband, and these art works were usually signed "Will and F (monogram of FB) Brundage" or "W. and F. Brundage." We found one illustration signed "FLB" (monogram) that was definitely Brundage.

Frances and William Brundage lived in Washington, D. C., and spent the summer months at Cape Ann, Massachusetts. They later resided in Brooklyn, New York.

William Brundage, died in 1923. Frances survived him for 14 years and died on March 28, 1937, in Brooklyn, New York. She was 82 years old and had just completed a children's textbook on art called *It's Fun to Draw*.

It would be impossible to include all of the art of Frances Brundage in this book, but we have tried to offer a representative variety of her illustrations for your enjoyment. The following examples are from a 50-year-old collection of the art of Frances Brundage. Her work spans many decades, and has added much pleasure and beauty to our lives. The search for her things is never ending and the printing here of some of our favorites is just the "tip of the iceberg"—a bit of Brundage!

—Sarah Steier and Donna Braun

Chapter One
Books

Frances Brundage illustrated many more than the books and booklets included here. Our list is not a complete one, since we continue to find Brundage books and are sure she illustrated many more.

Some books contain both verses and illustrations by Frances Brundage, such as *The Cat's Pajamas, Adventures of Jack, Snow White and Rose Red,* and *What Happened to Tommy?*—all published by Stecher Lithography Co., Rochester, N. Y.

Only a few of her books contain duplicate images that were published elsewhere. These include *Holiday Stories,* which shares some images with *Childhood,* and *Tales from Longfellow,* which has some of the same images as *Father Tuck's Annual* (No. 5170). *Little Men and Maids* and *Little Belles and Beaux* each have 6 of the 12 images that are in *Children of Today.* Some publishers, such as Saalfield, issued different sizes of the same book.

The most collectible and rarest books are the ones containing the color plates of beautiful children. The following illustrations are from her numerous books and show a variety of her art, produced during the late nineteenth and early twentieth centuries.

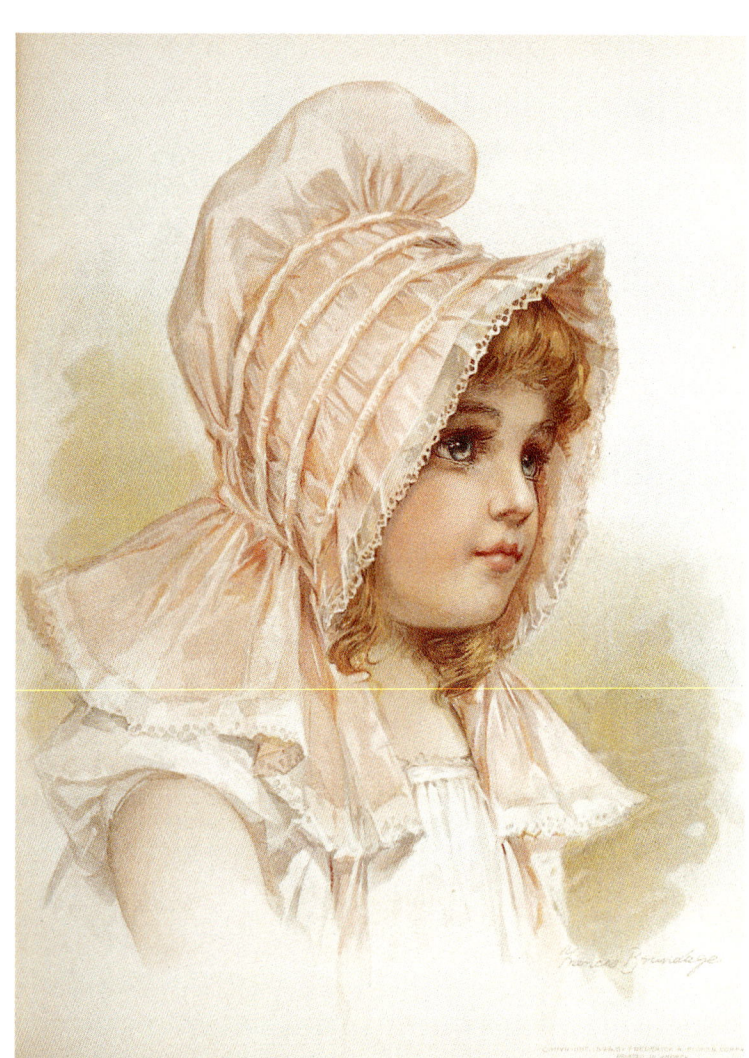

Illustration is from *Children of Today* published by Fred A. Stokes Co., 1896.

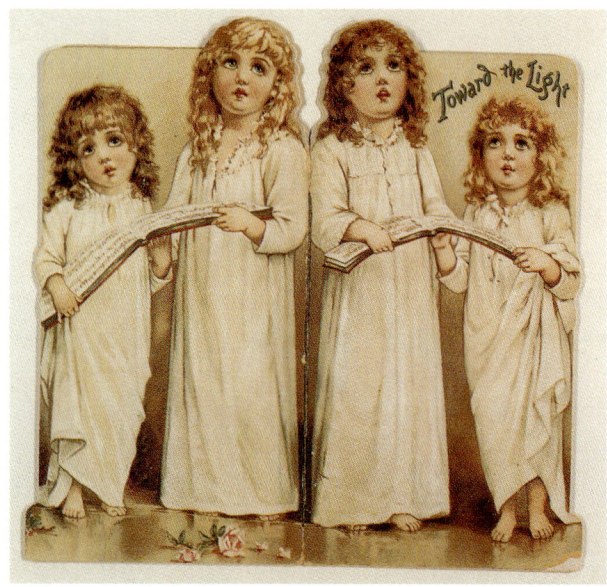

Illustration is from cover of *Toward the Light* published by Raphael Tuck & Sons.

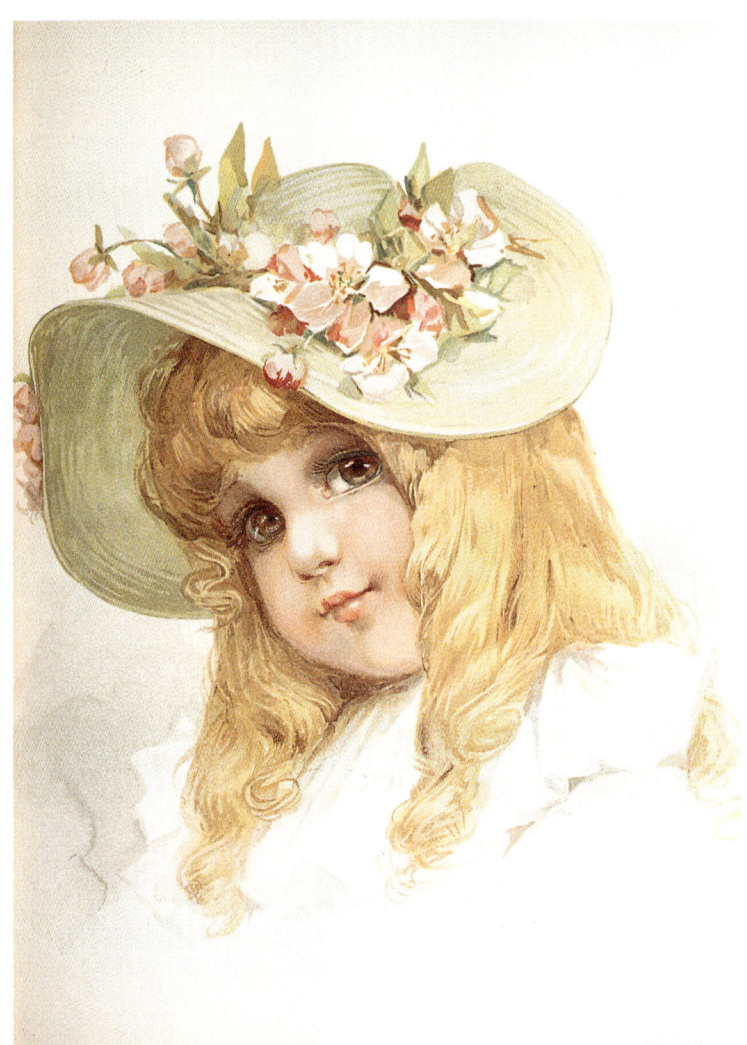
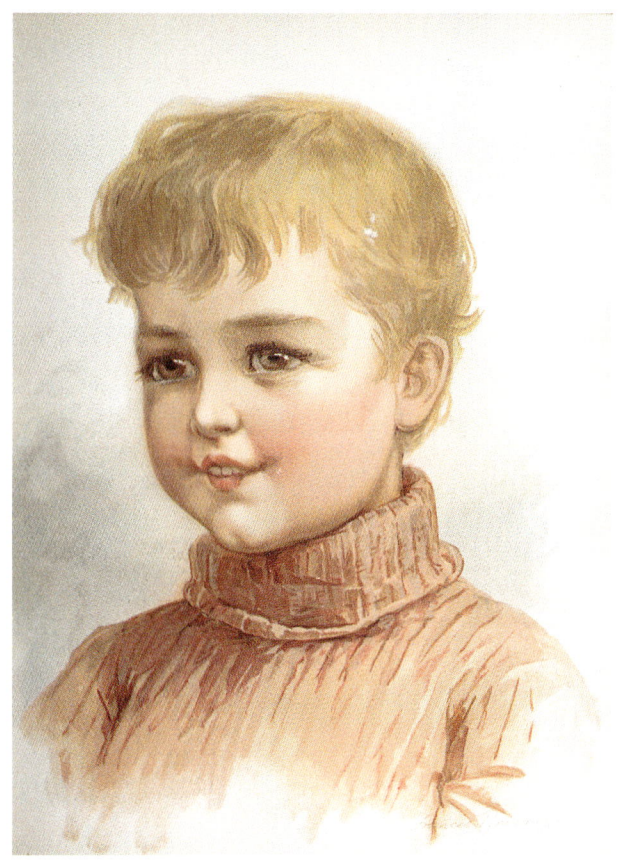

Illustration is from *Children of Today*
published by Fred A. Stokes Co., 1896.

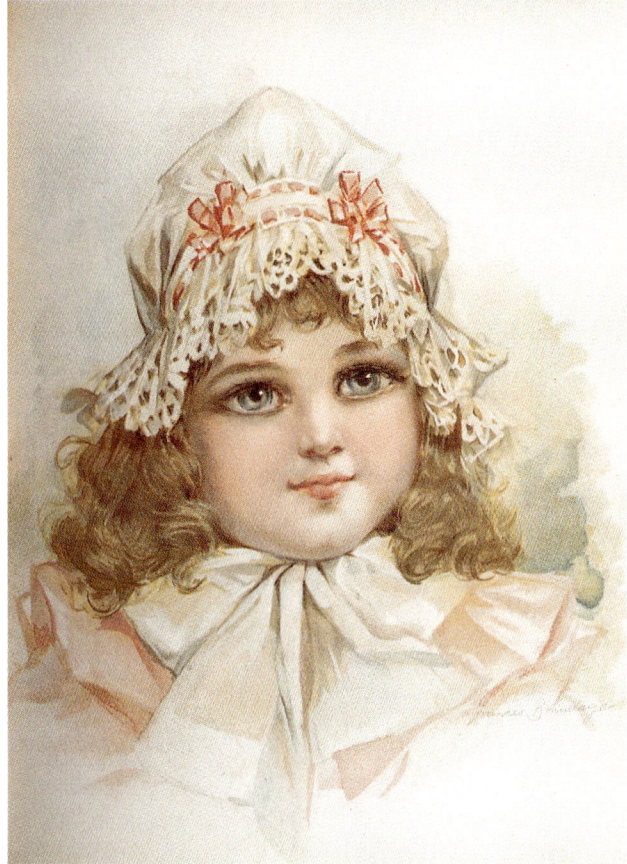
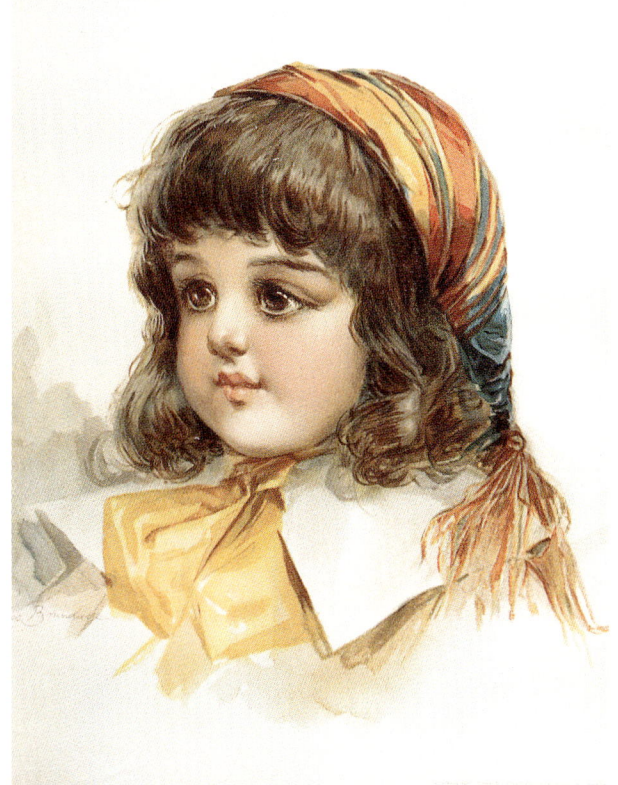

Left and above two:
Children of Today published
by Fred A. Stokes Co.

7

Children of Today published by Fred A. Stokes Co.

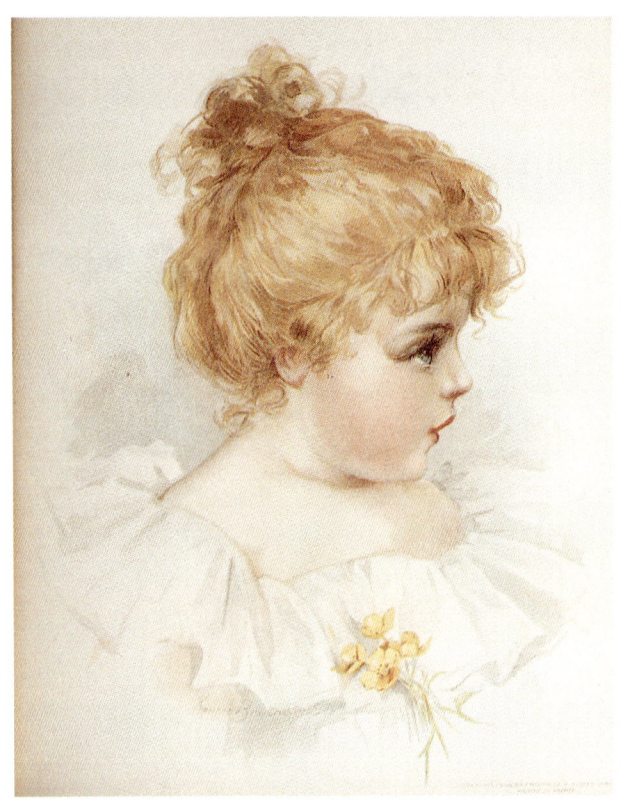
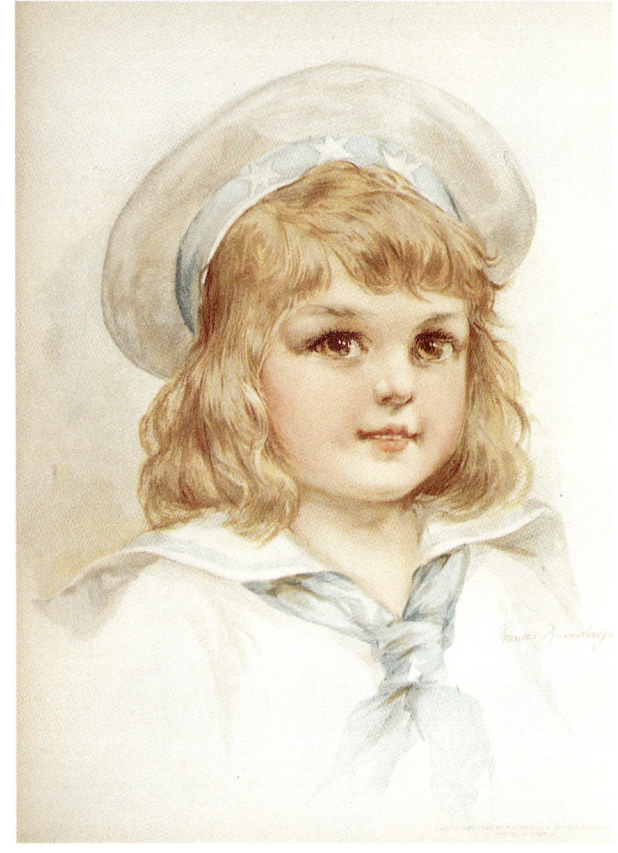
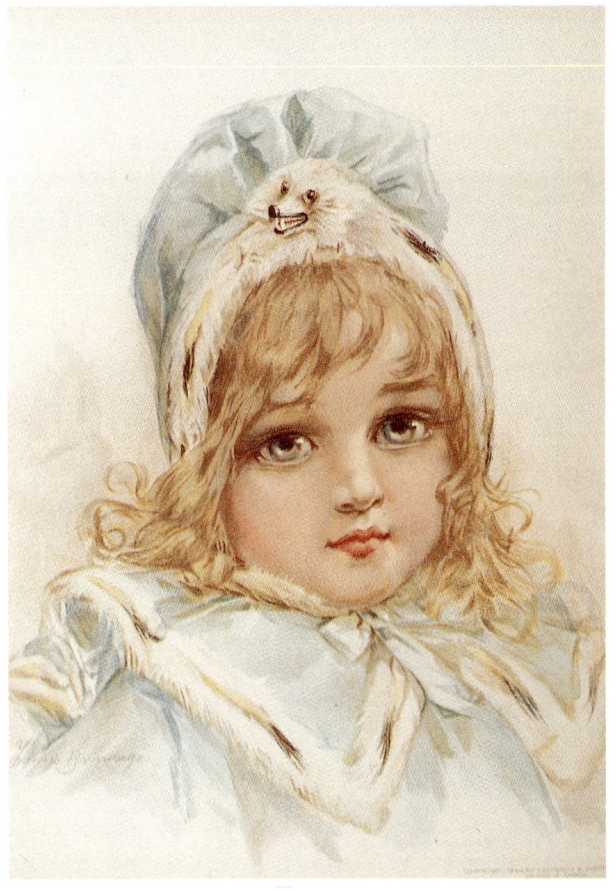
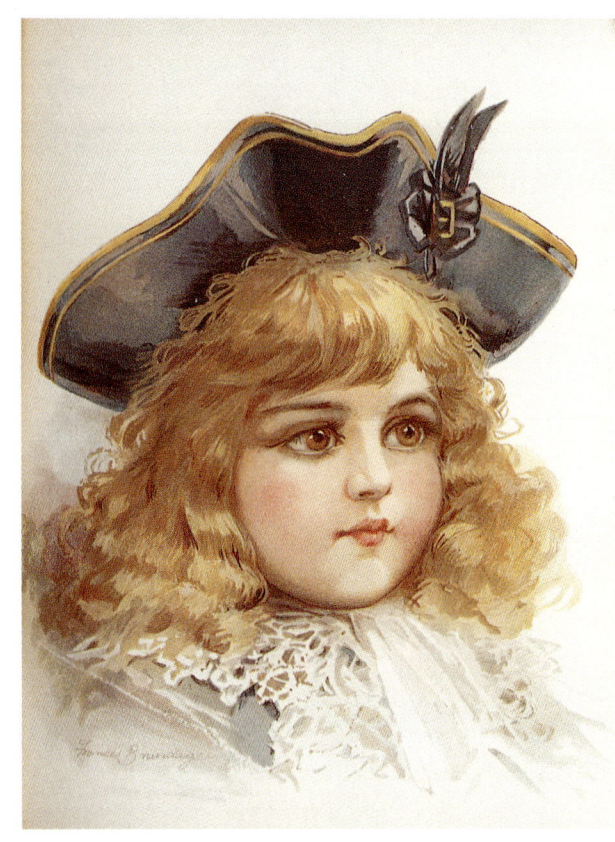

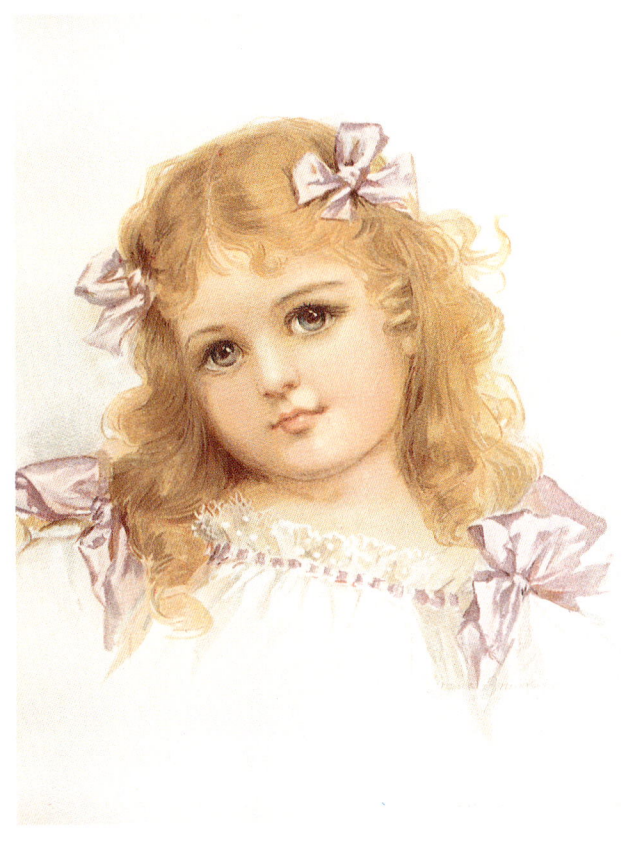
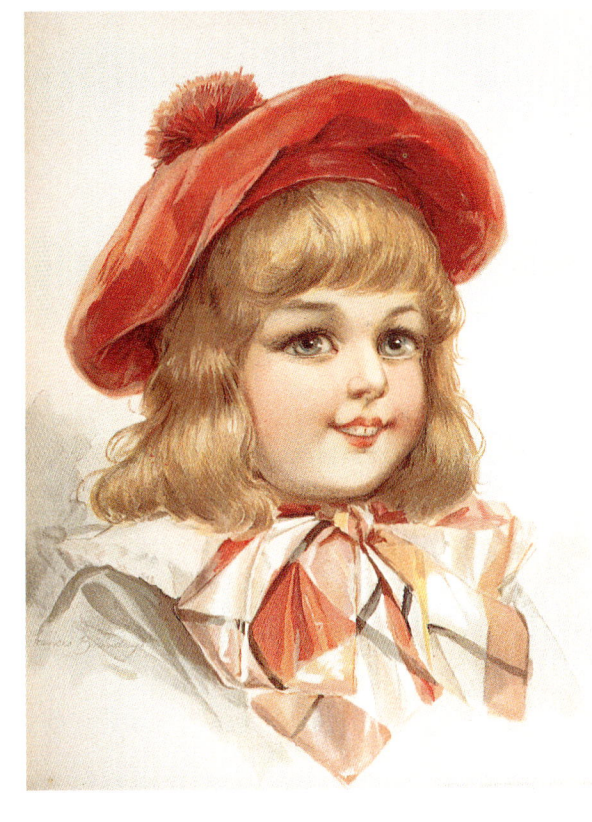
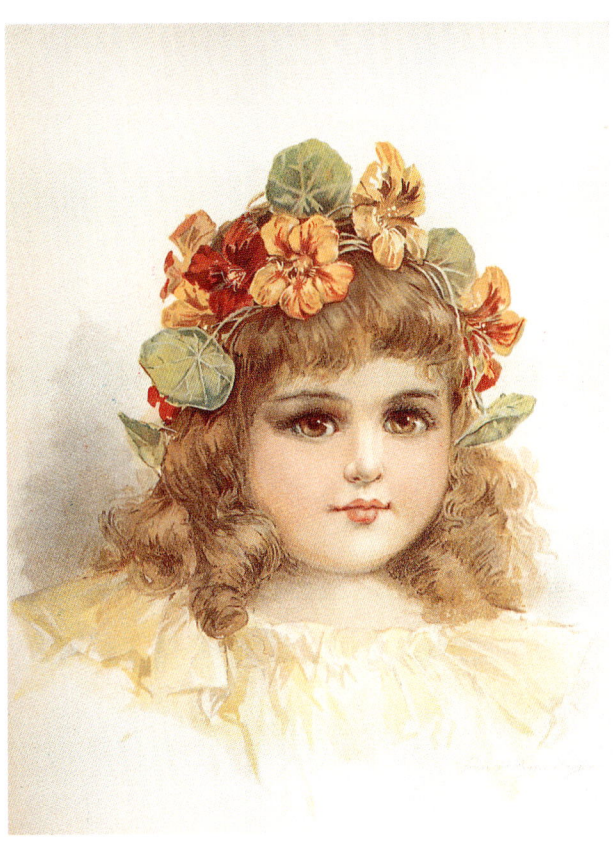

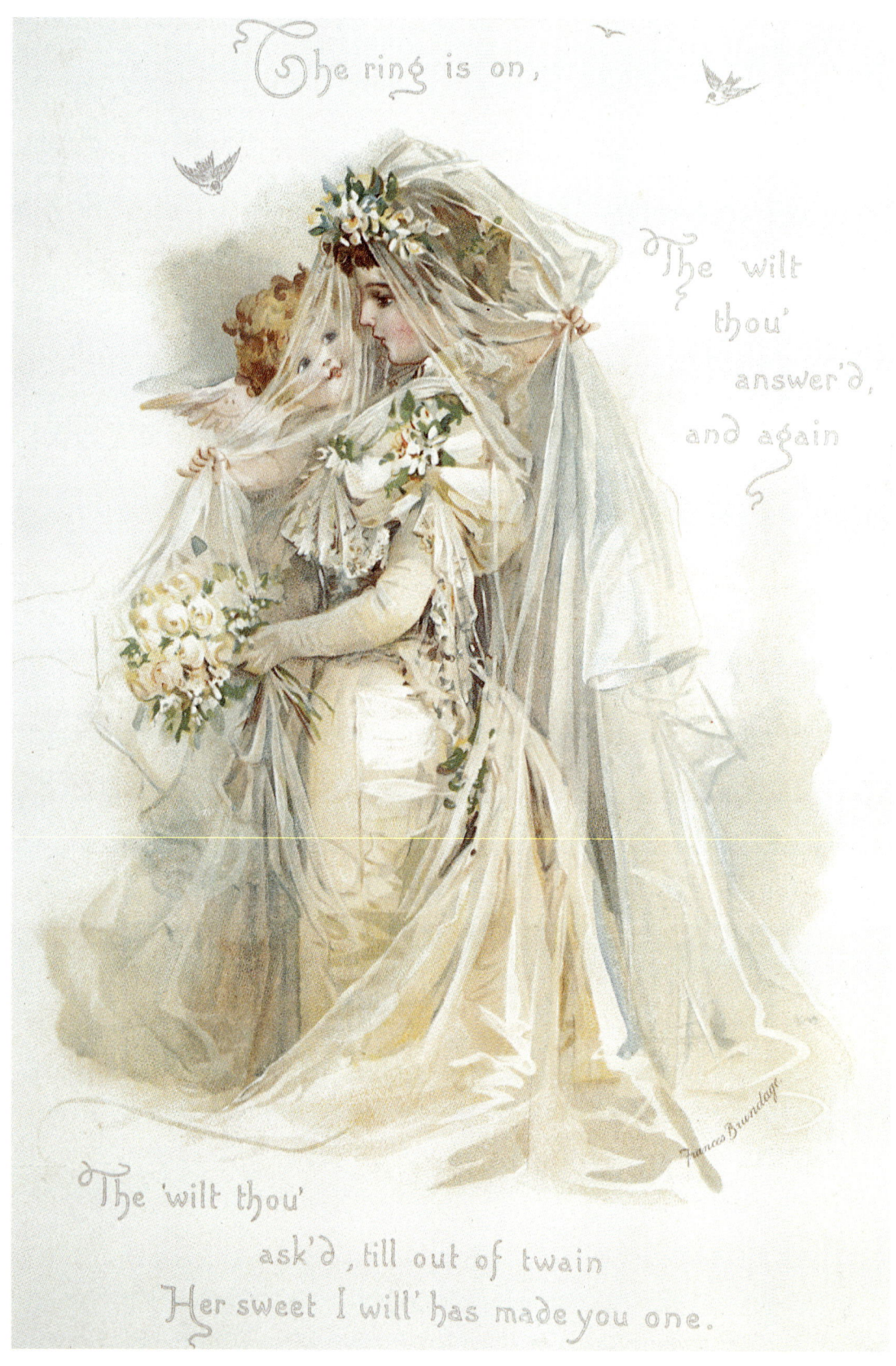

Illustration is from *Wedding Bells*
published by Raphael Tuck & Sons.

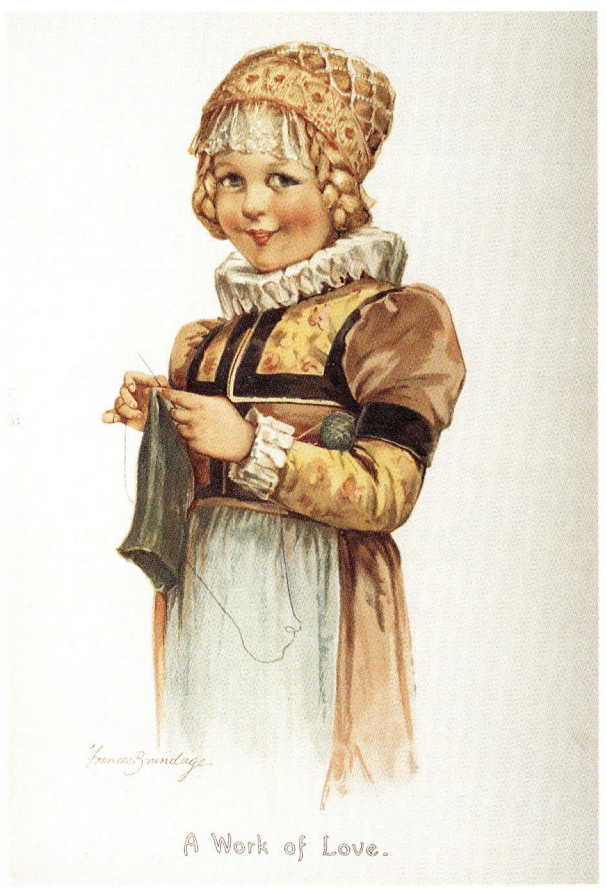

"A Work of Love" from *Hours in Many Lands* published by Raphael Tuck & Sons.

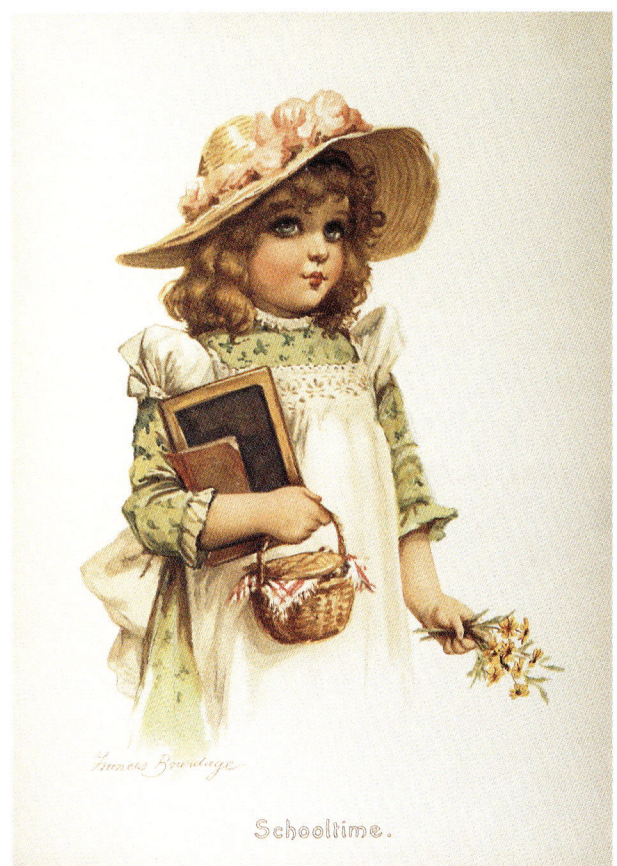

"Schooltime" from *Hours in Many Lands* published by Raphael Tuck & Sons.

"Pepita" from *Hours in Many Lands* published by Raphael Tuck & Sons.

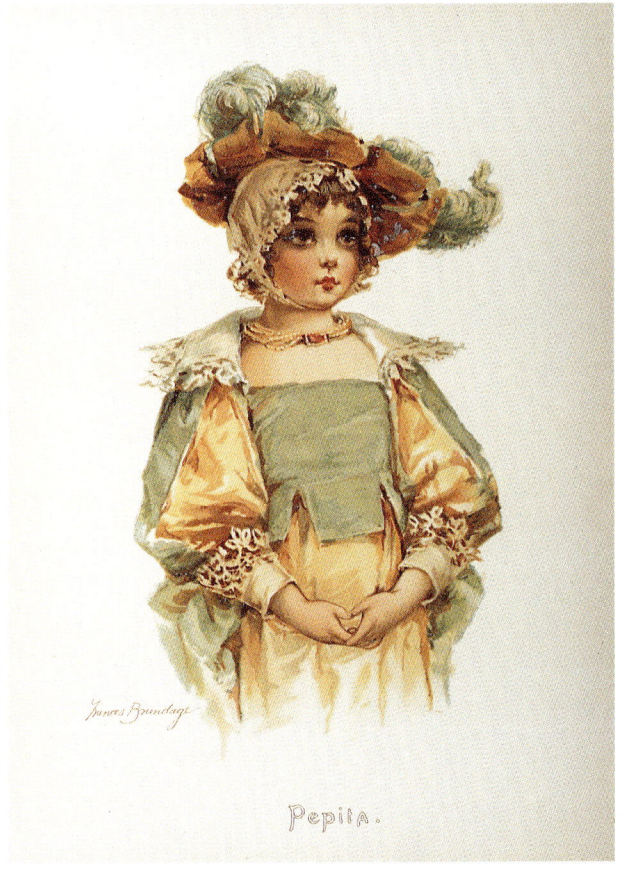

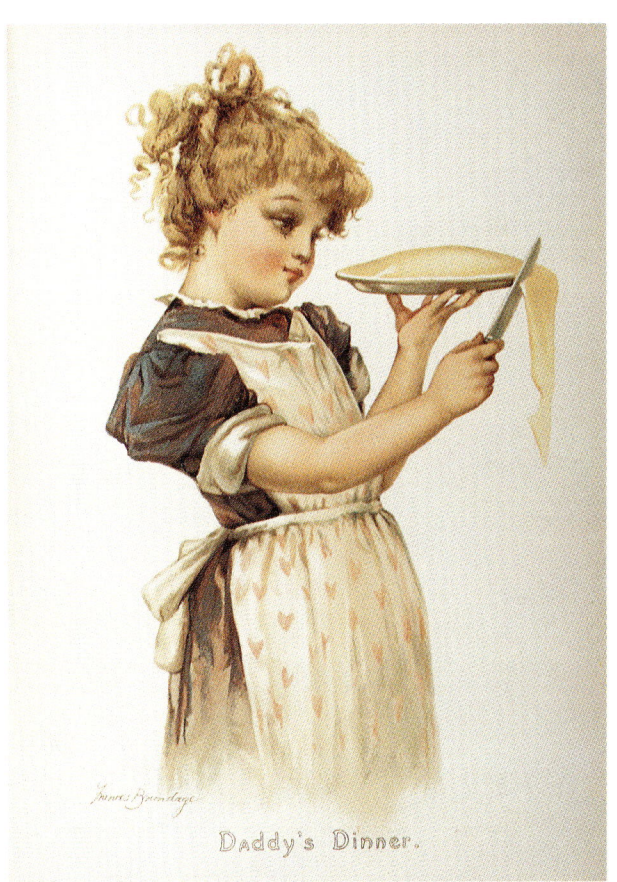

"Daddy's Dinner" from *Hours in Many Lands* published by Raphael Tuck & Sons.

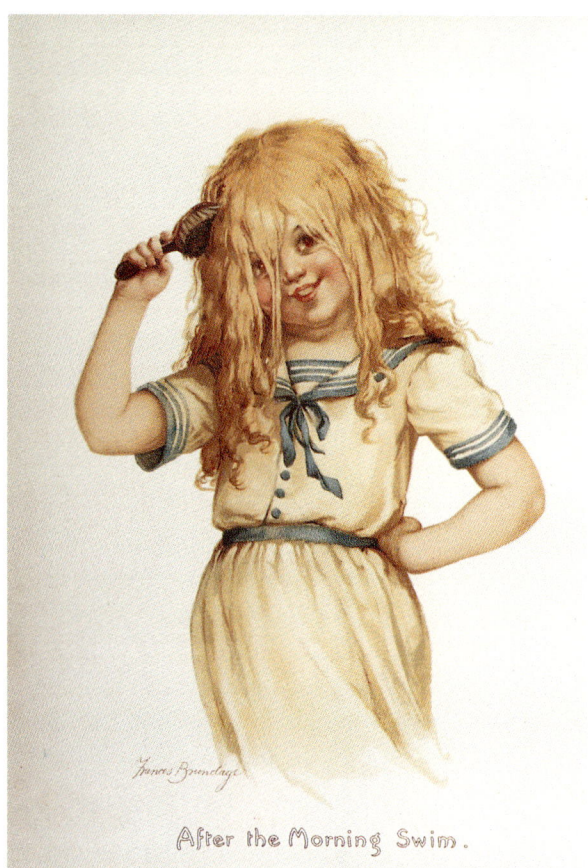

"After the Morning Swim" from *Hours in Many Lands* published by Raphael Tuck & Sons.

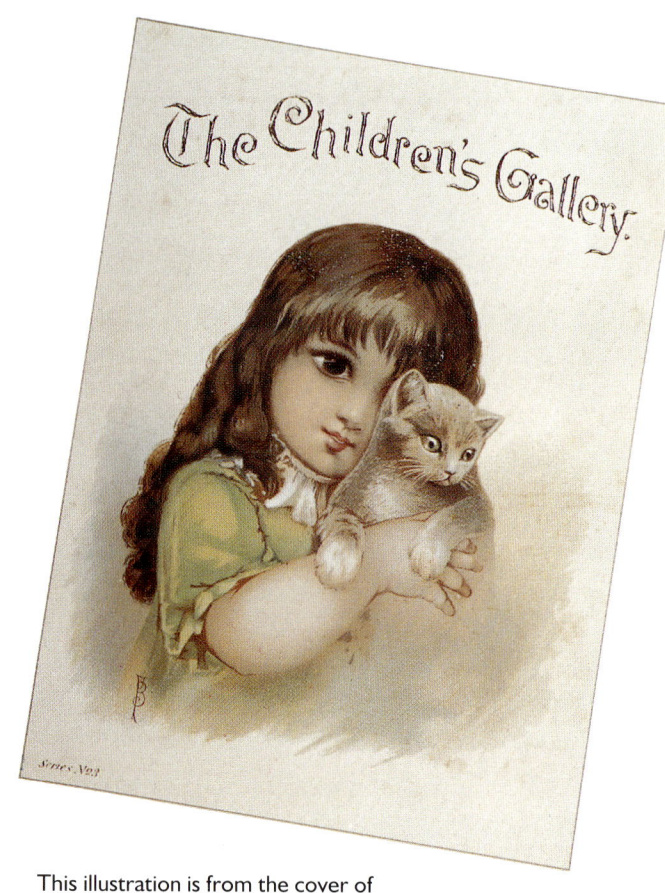

This illustration is from the cover of *The Children's Gallery* published by E. P. Dutton.

"Good Night" from *Hours in Many Lands* published by Raphael Tuck & Sons.

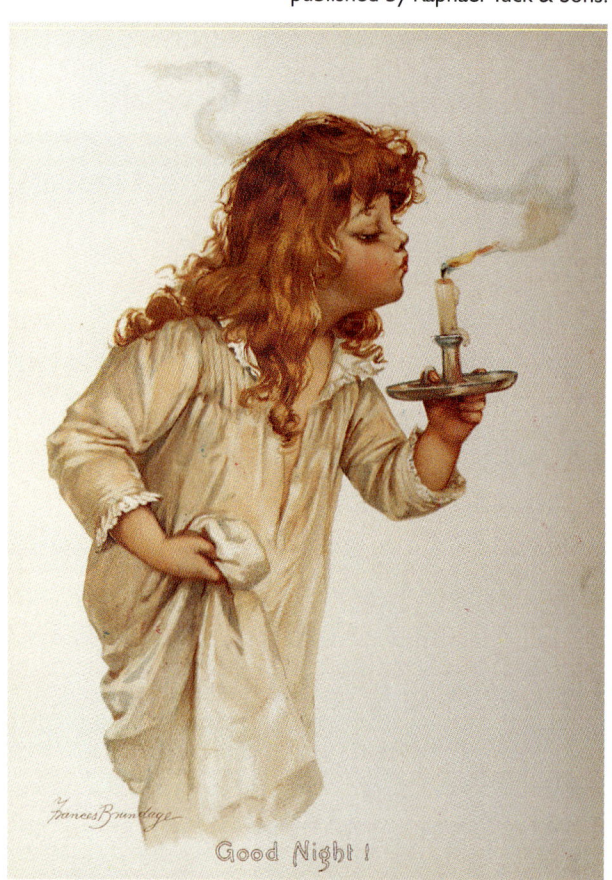

Below and following: Illustrations from *The Children's Gallery* published by E. P. Dutton.

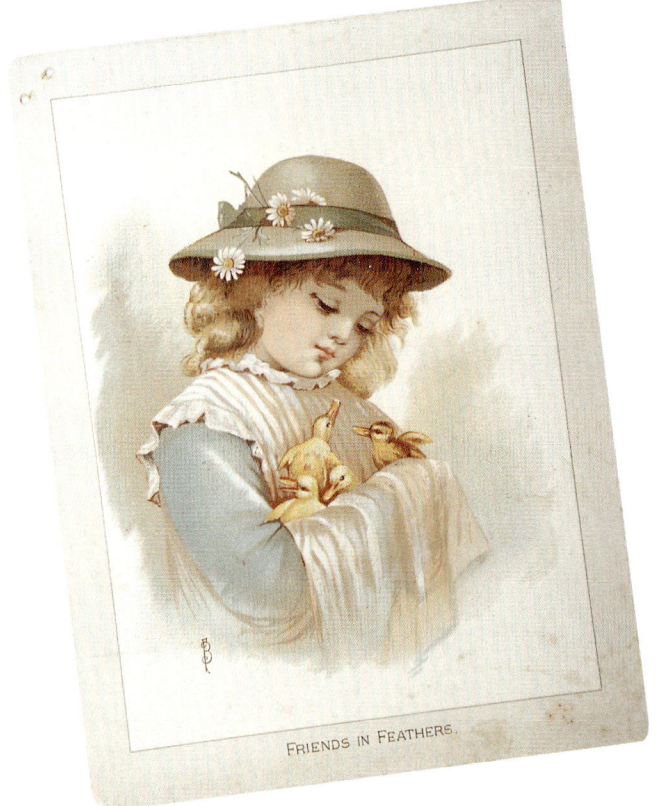

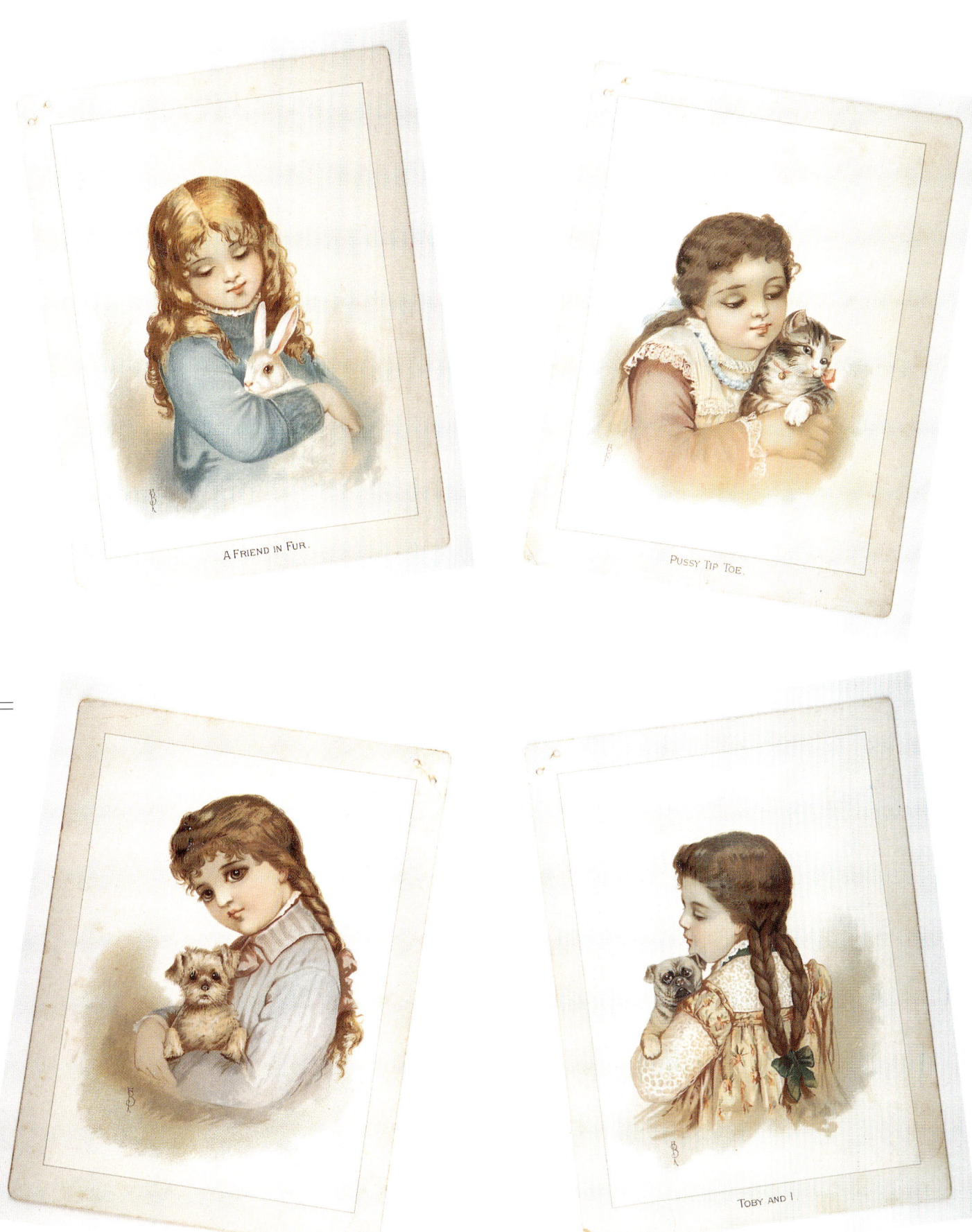

These eight illustrations are from *Our Little Men and Maidens* published by Ernest Nister and E. P. Dutton. These images were also in calendar form as well as die-cuts.

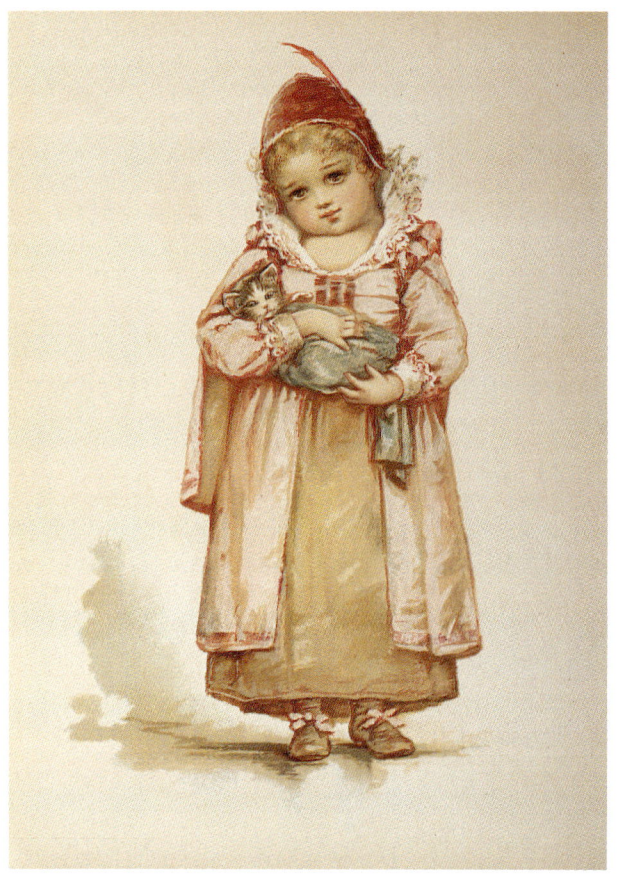
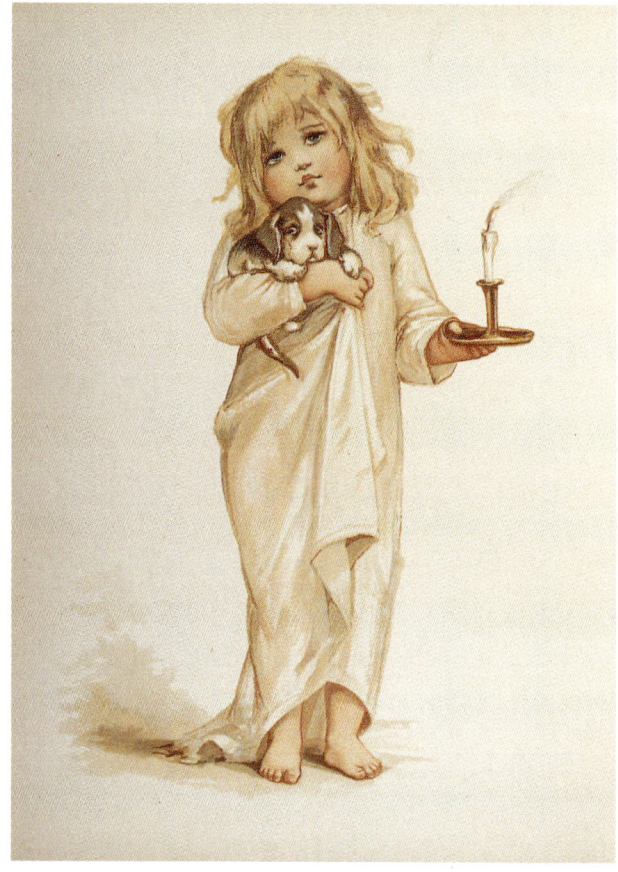
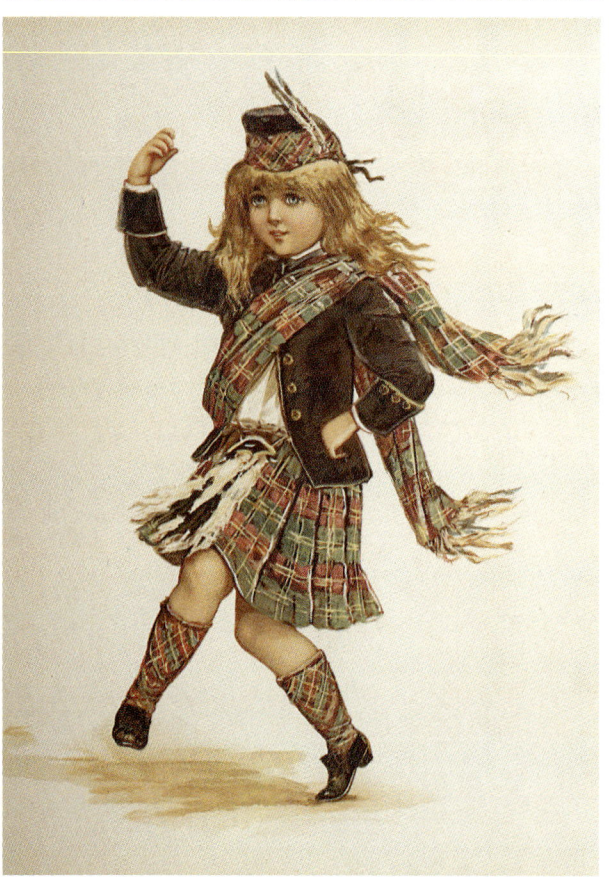
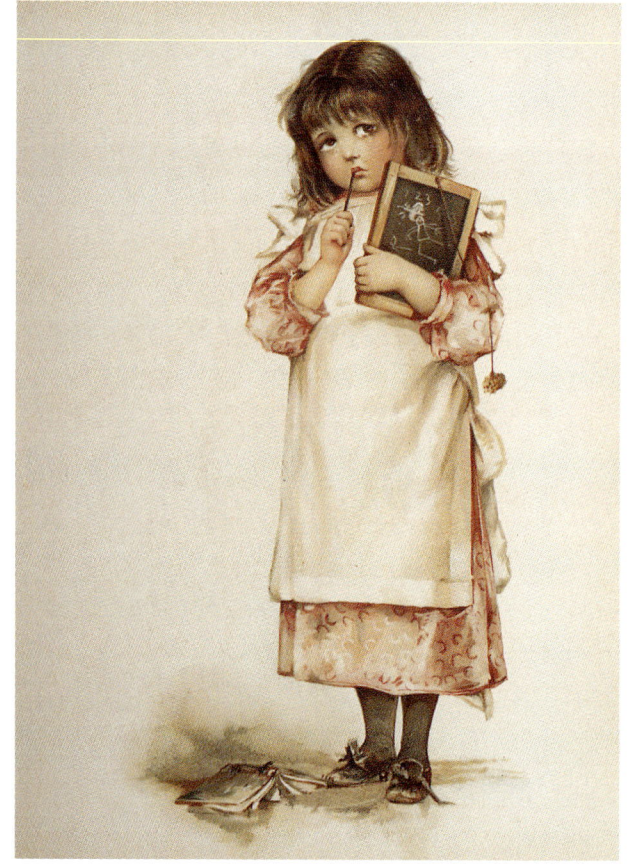

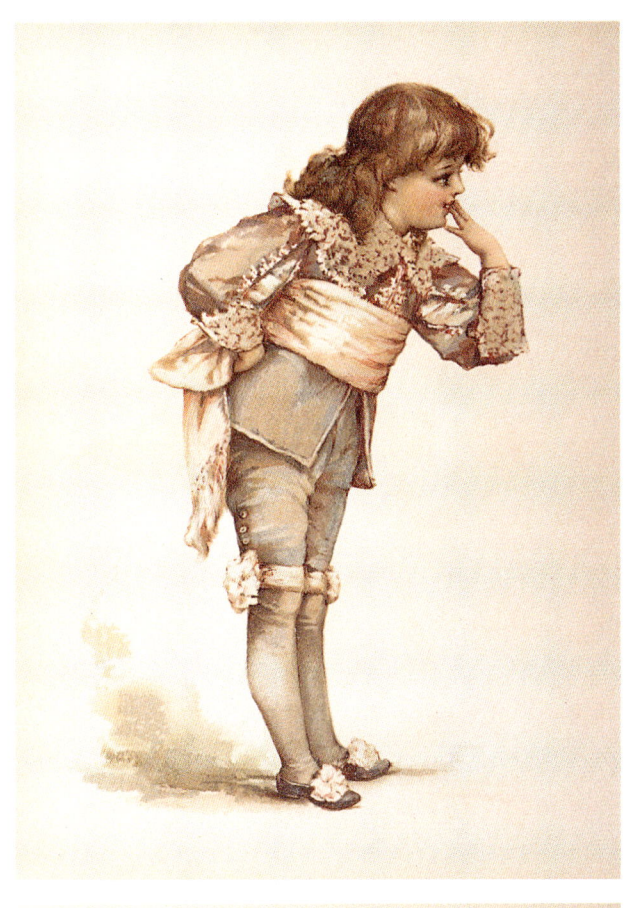
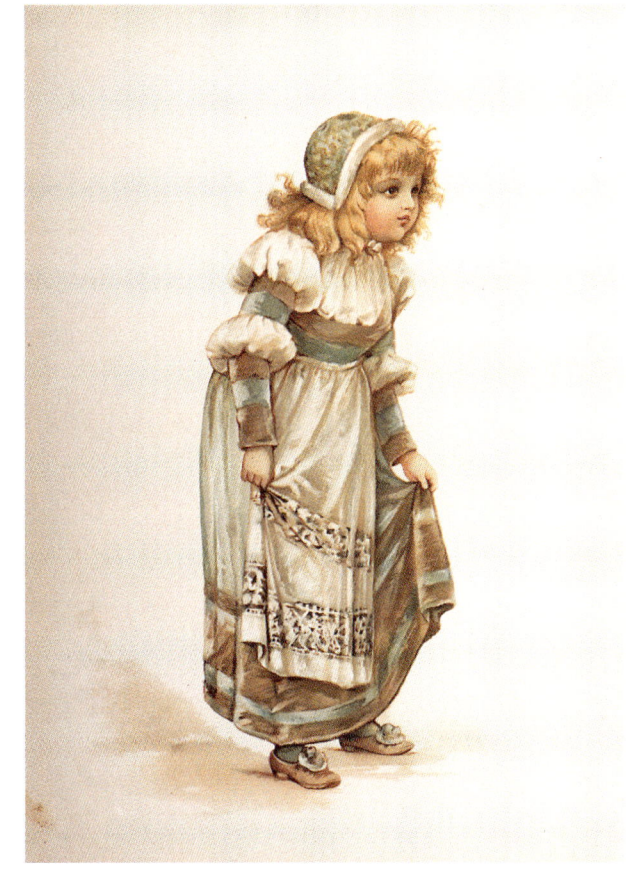
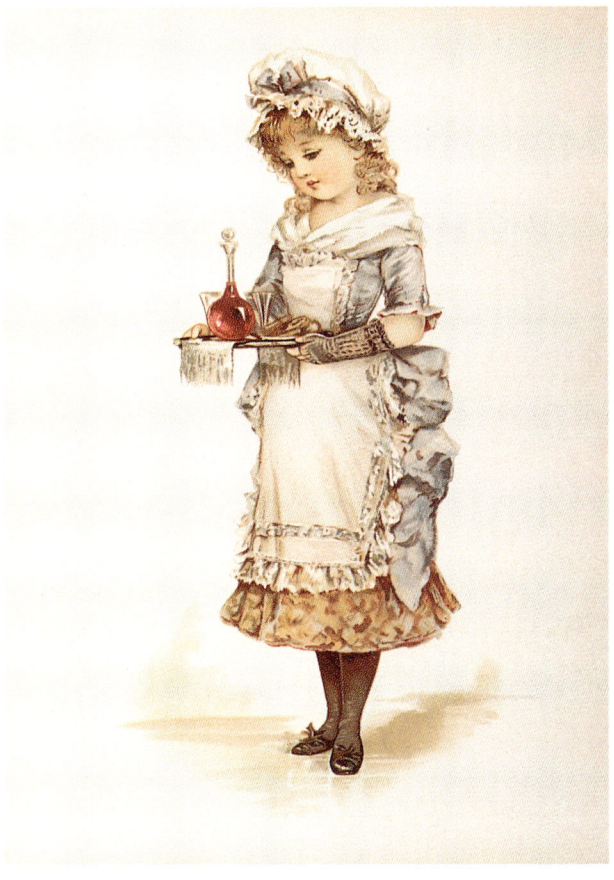
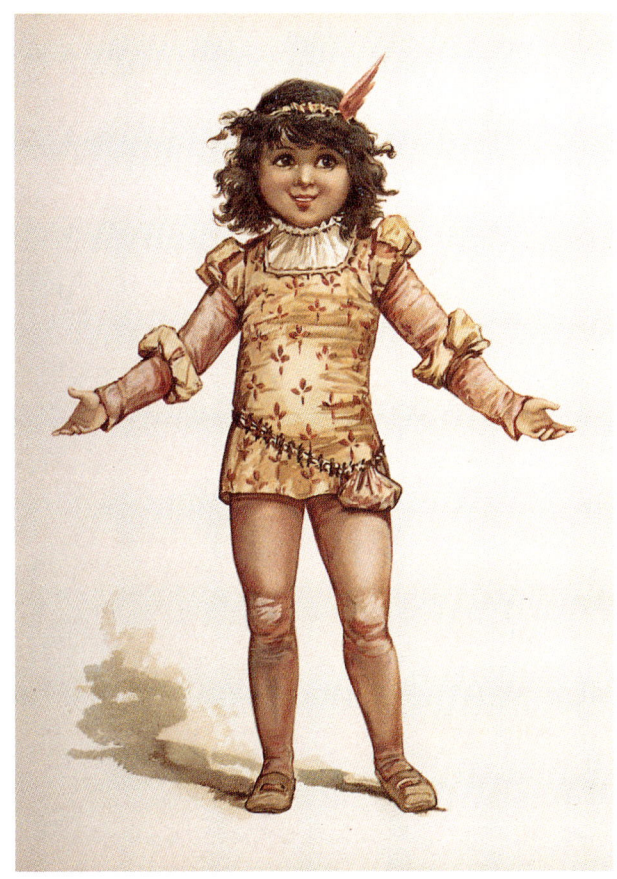

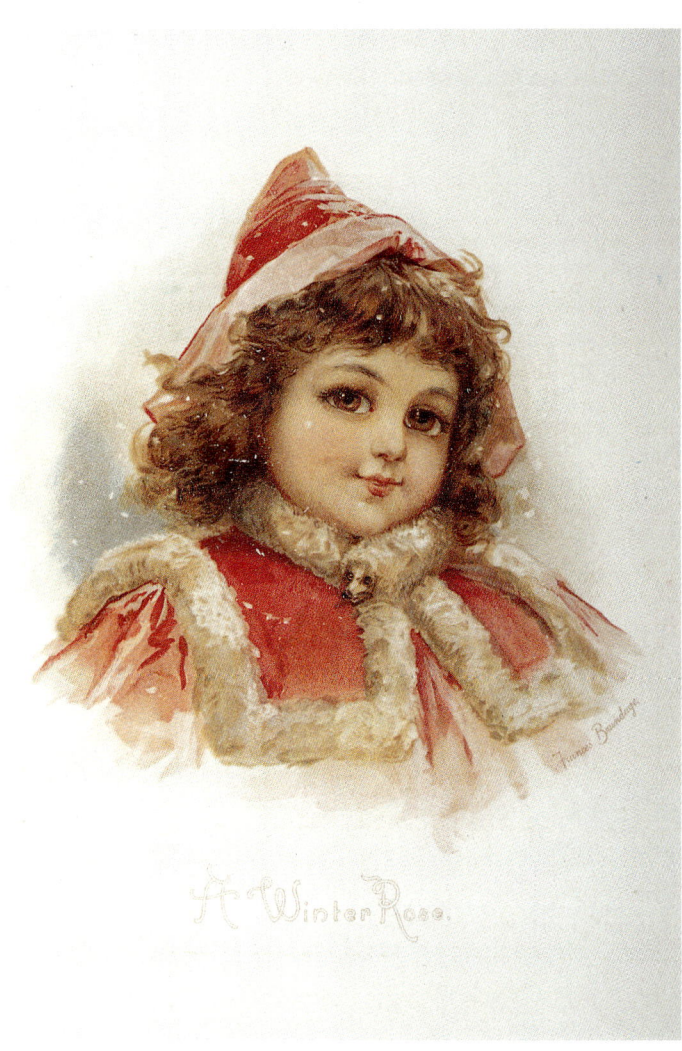

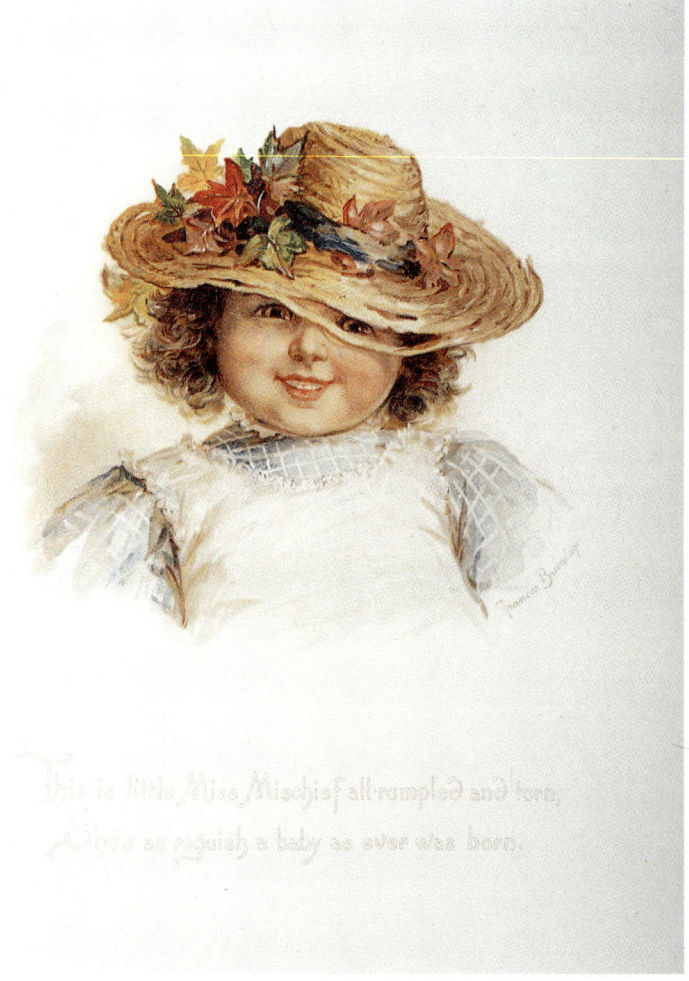

Left and below:
Illustrations are from *Little Bright Eyes* published by Raphael Tuck & Sons.

Little Bright Eyes published by Raphael Tuck & Sons.

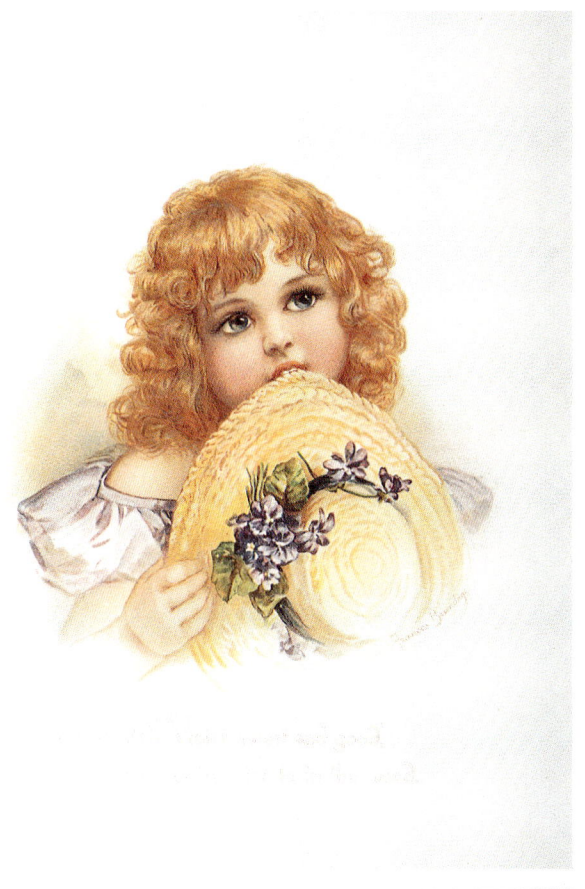

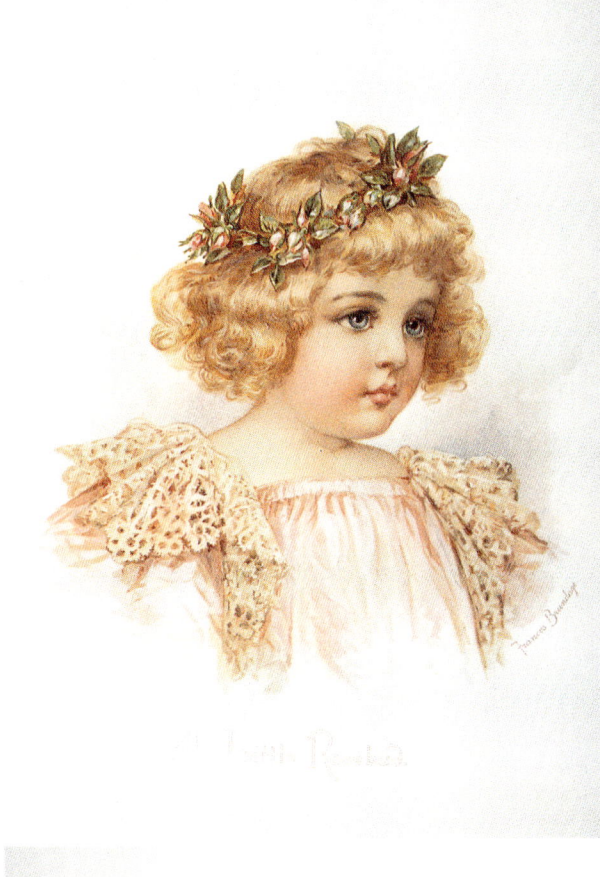

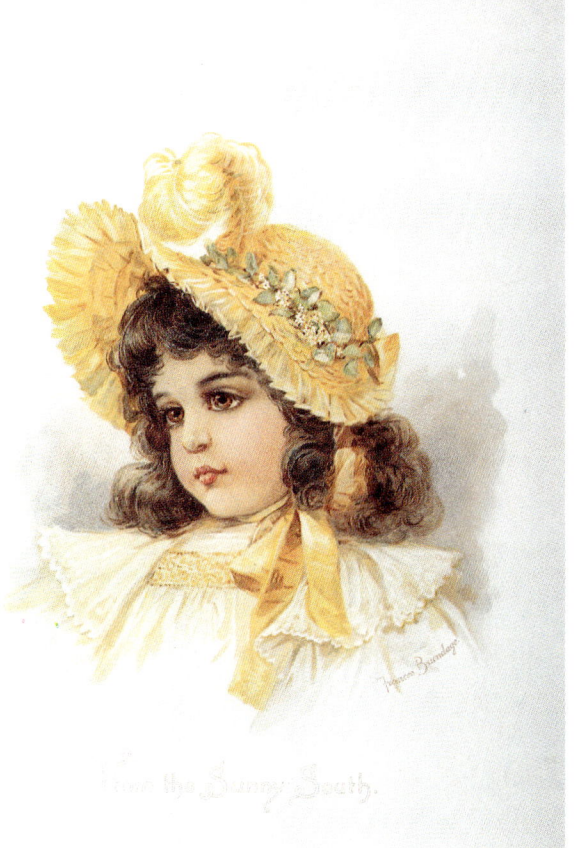

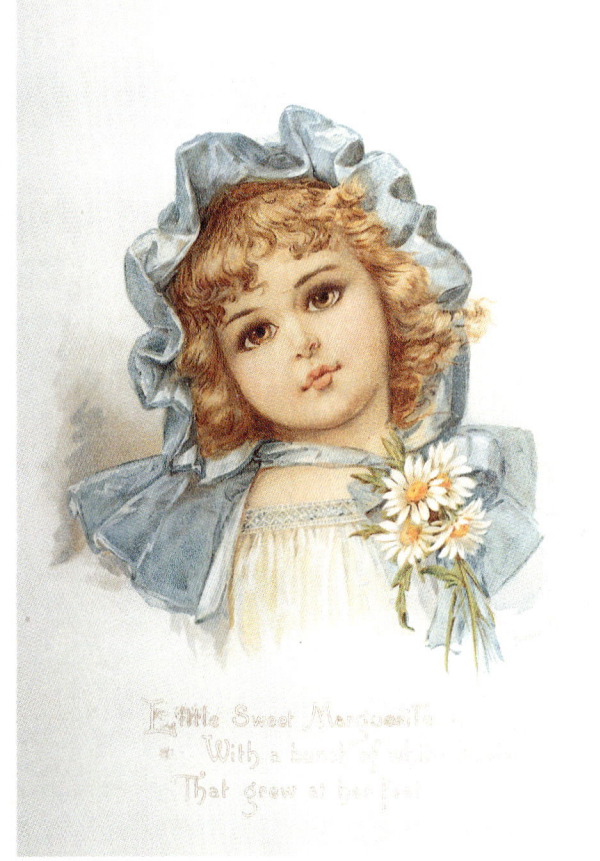

Illustrations are from *Frolic for Fun* published by Saalfield Publishing Co.

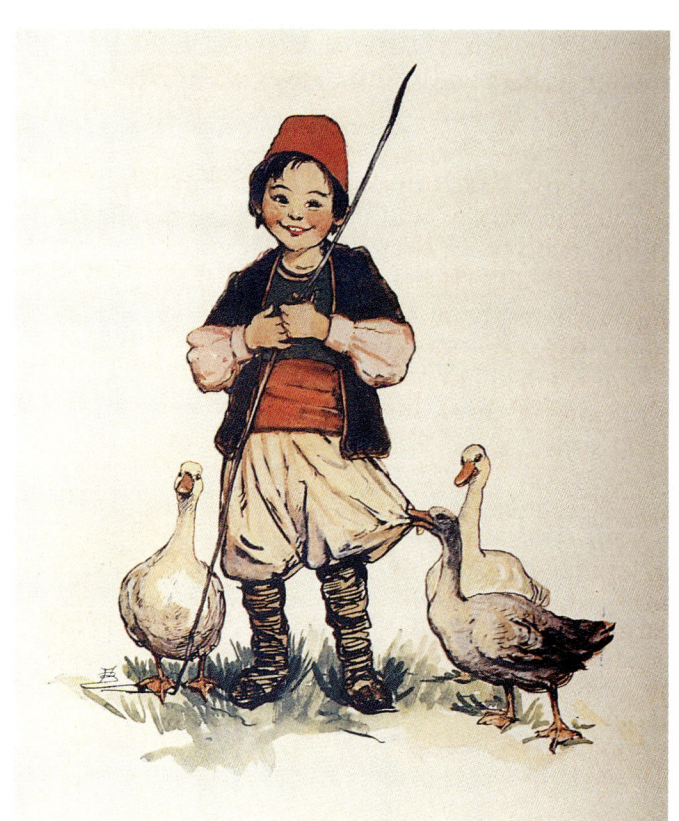

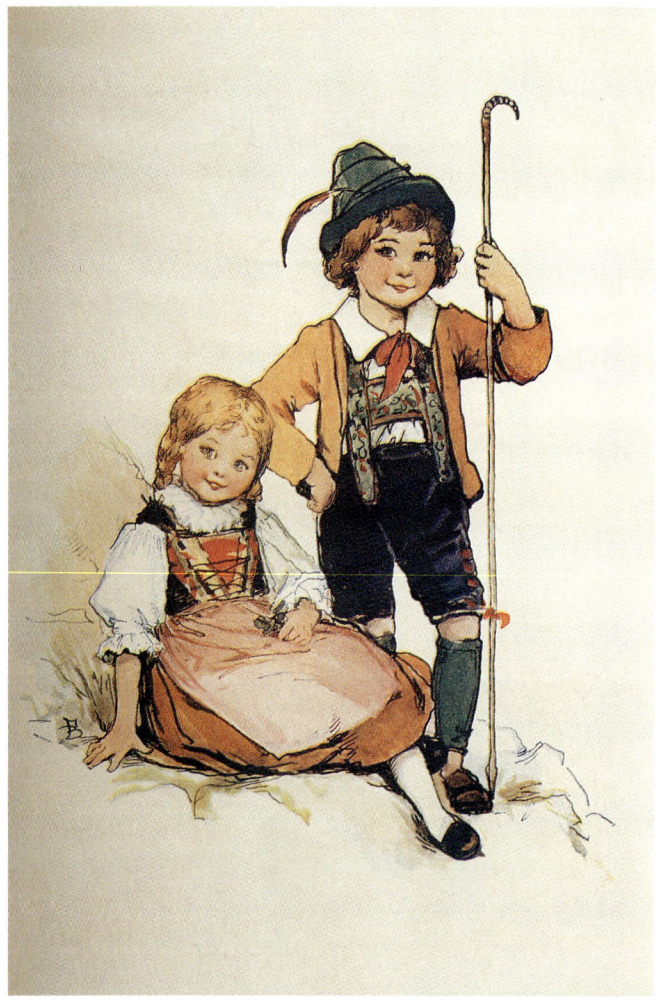

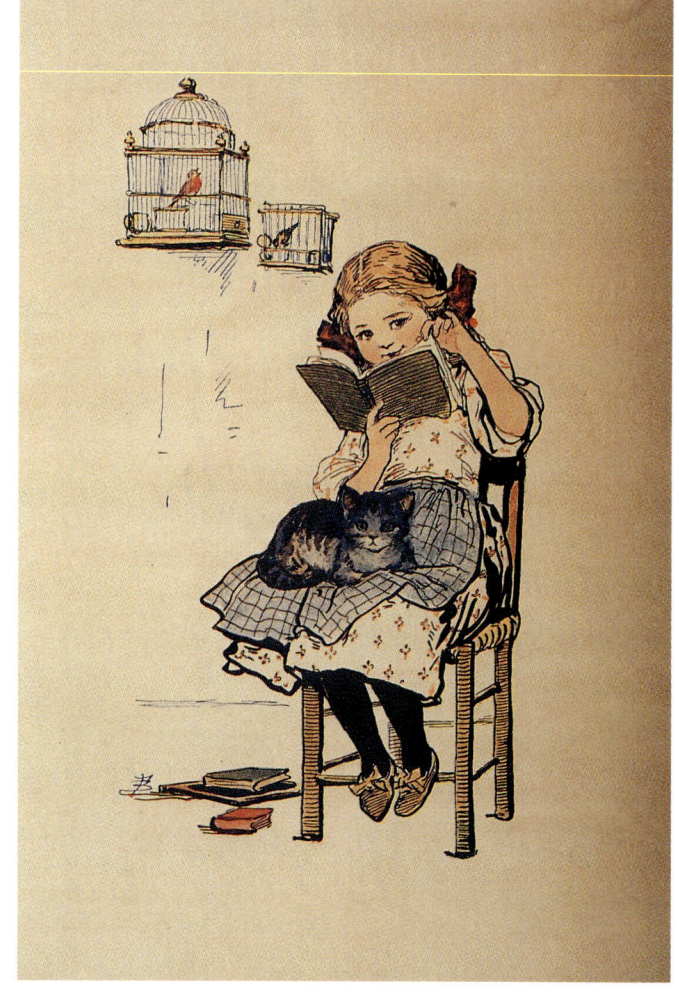

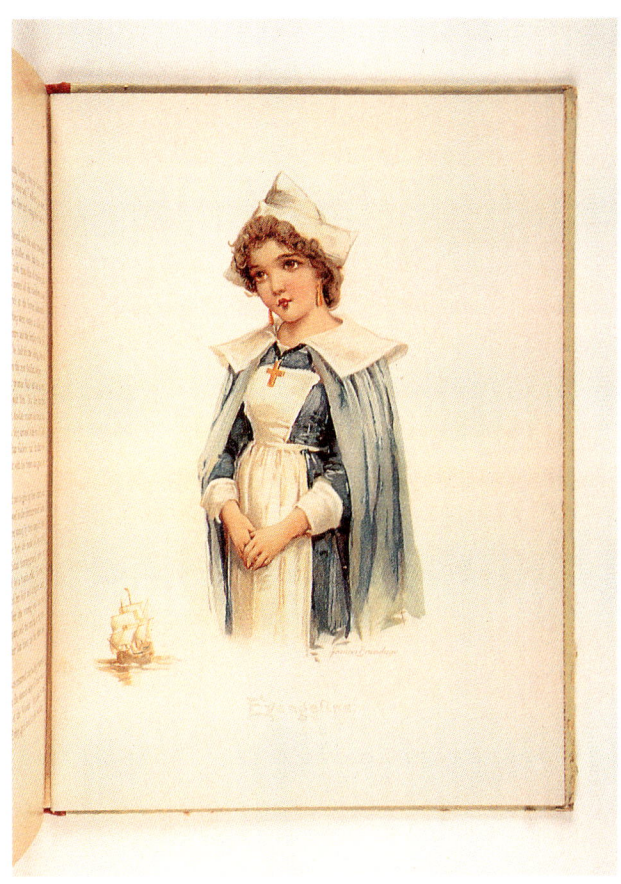

"Evangeline" from *Tales from Longfellow*
published by Raphael Tuck & Sons.

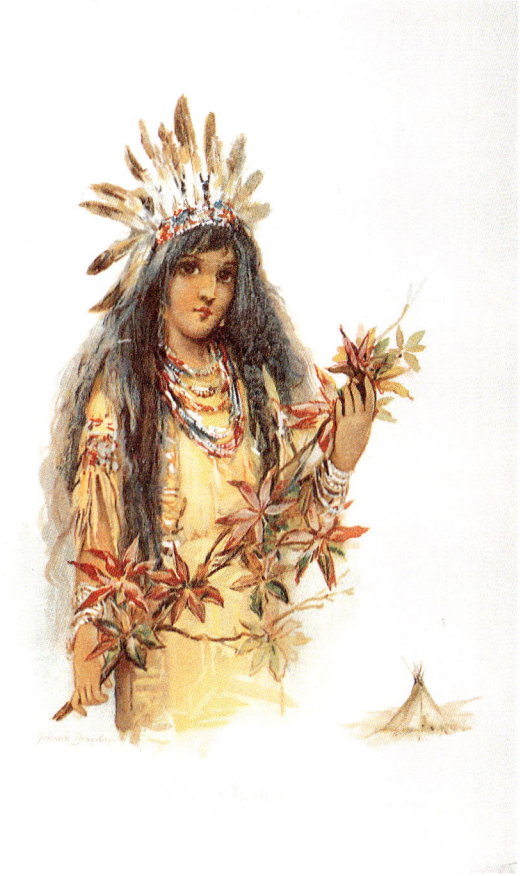

"Minnehaha" from *Tales from Longfellow*
published by Raphael Tuck & Sons.

"Priscilla" from *Tales from Longfellow*
published by Raphael Tuck & Sons.

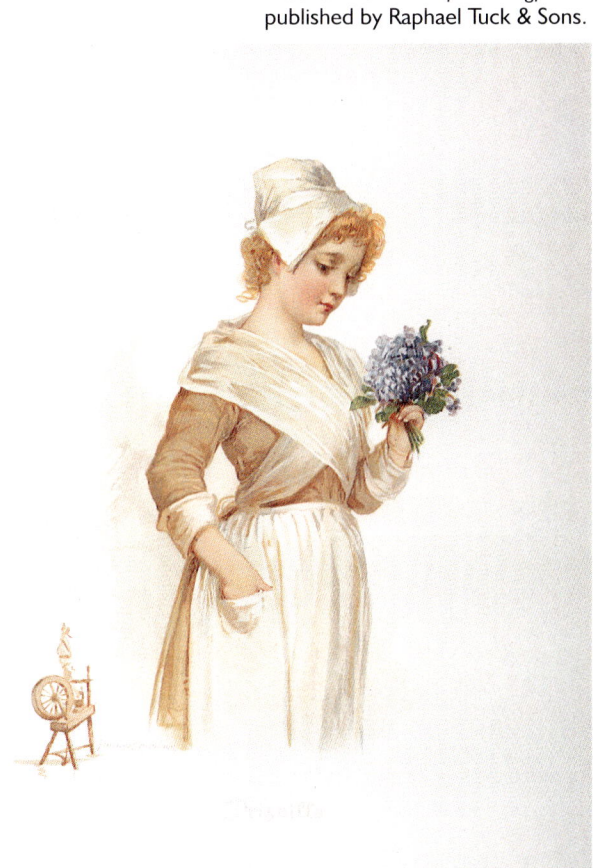

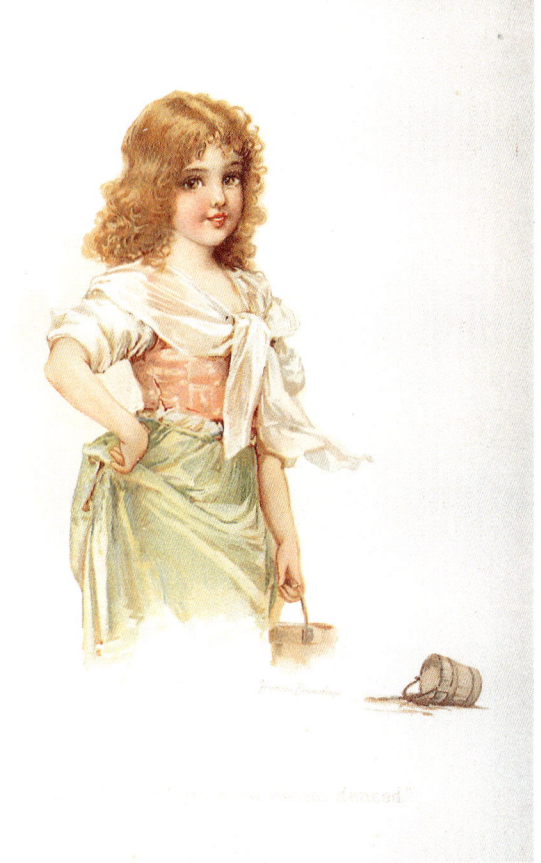

Illustration from *Tales from Longfellow*
published by Raphael Tuck & Sons.

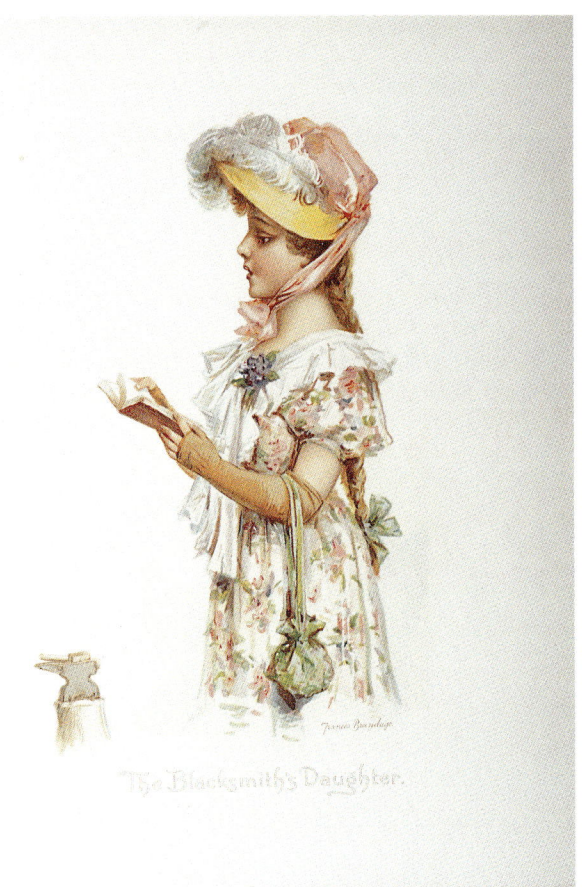

"The Blacksmith's Daughter" from *Tales from Longfellow* published by Raphael Tuck & Sons.

Illustration from *Tales from Longfellow* published by Raphael Tuck & Sons.

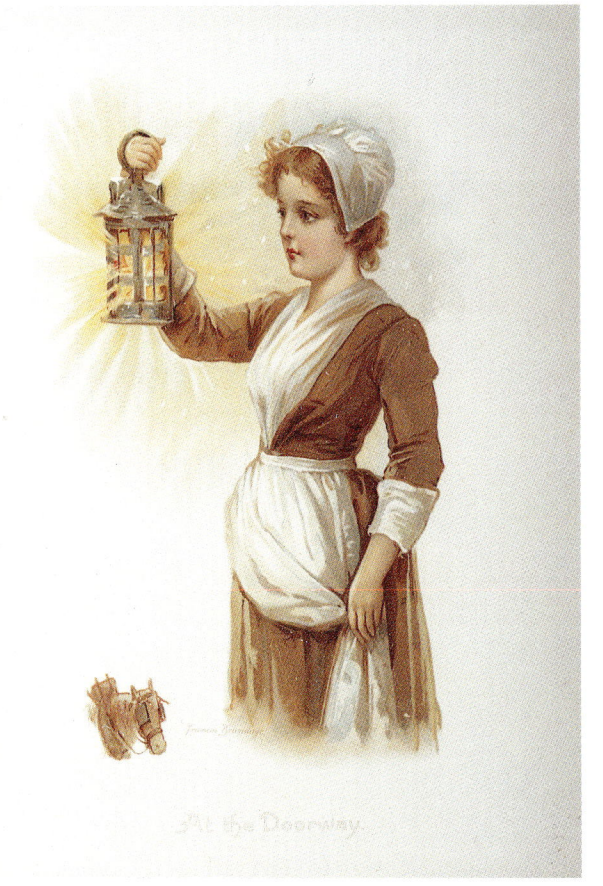

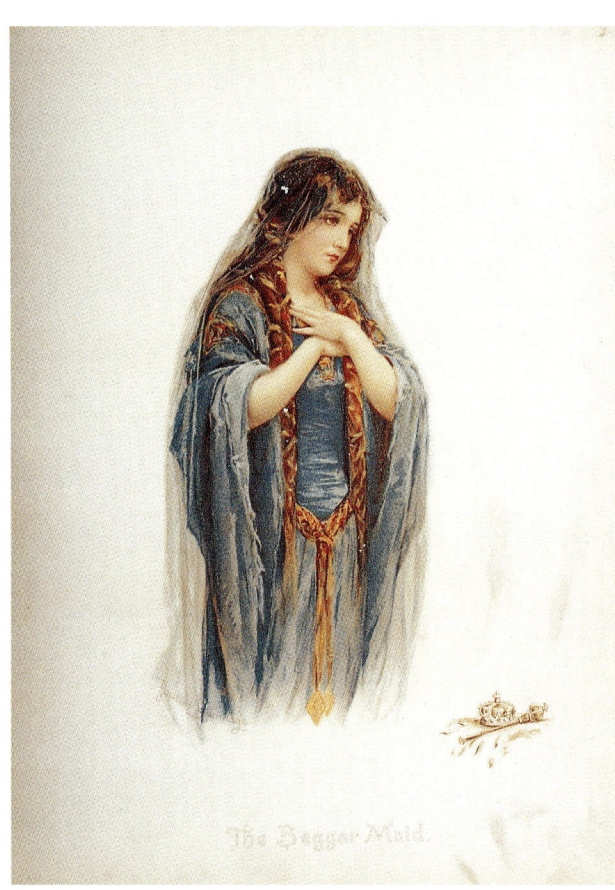

"The Beggar Maid" from *Tales from Tennyson* published by Raphael Tuck & Sons.

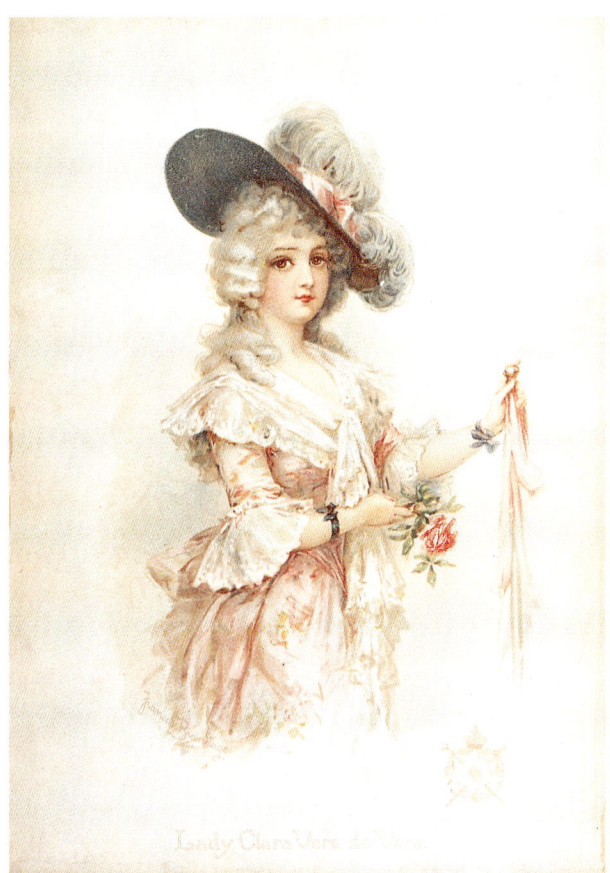

"Lady Clara Vere De Vere" from *Tales from Tennyson* published by Raphael Tuck & Sons.

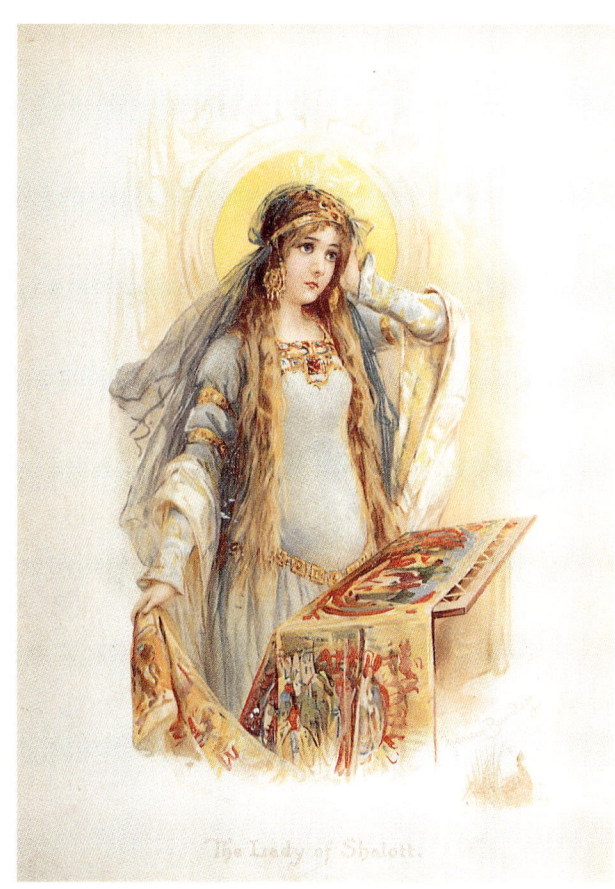

"Lady of Shalott" from *Tales from Tennyson* published by Raphael Tuck & Sons.

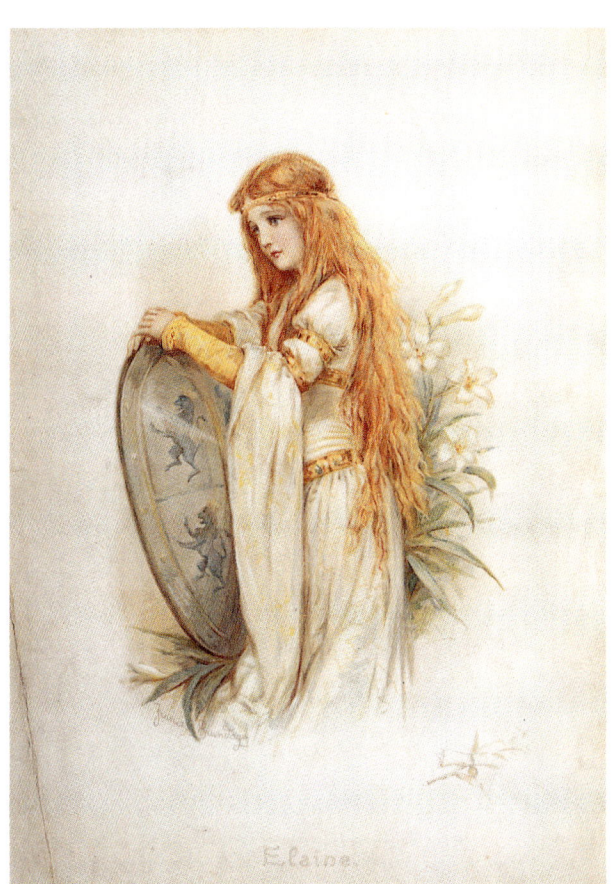

"Elaine" from *Tales from Tennyson* published by Raphael Tuck & Sons.

Illustrations from *Child Lyrics* published by Boston, De Wolfe, Fiske & Co.

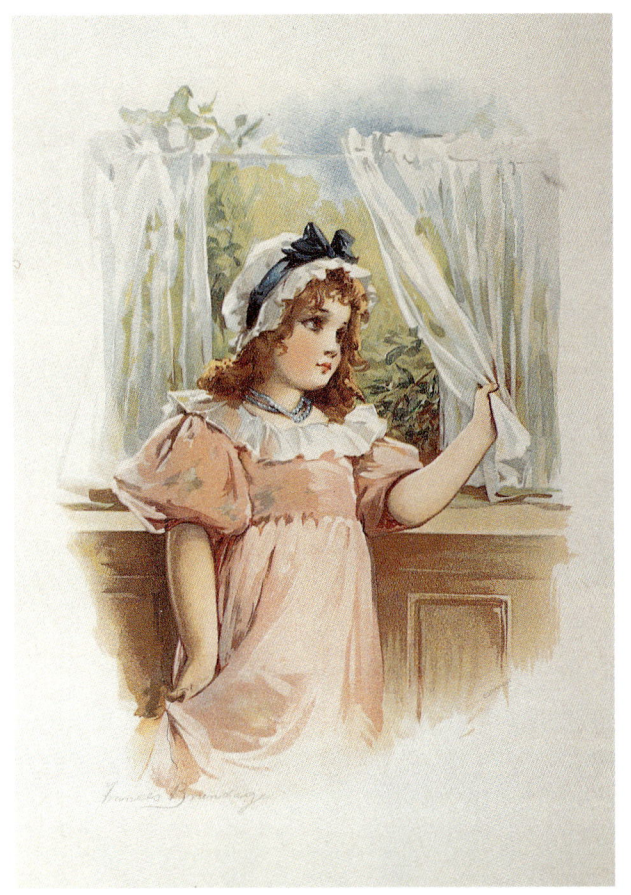
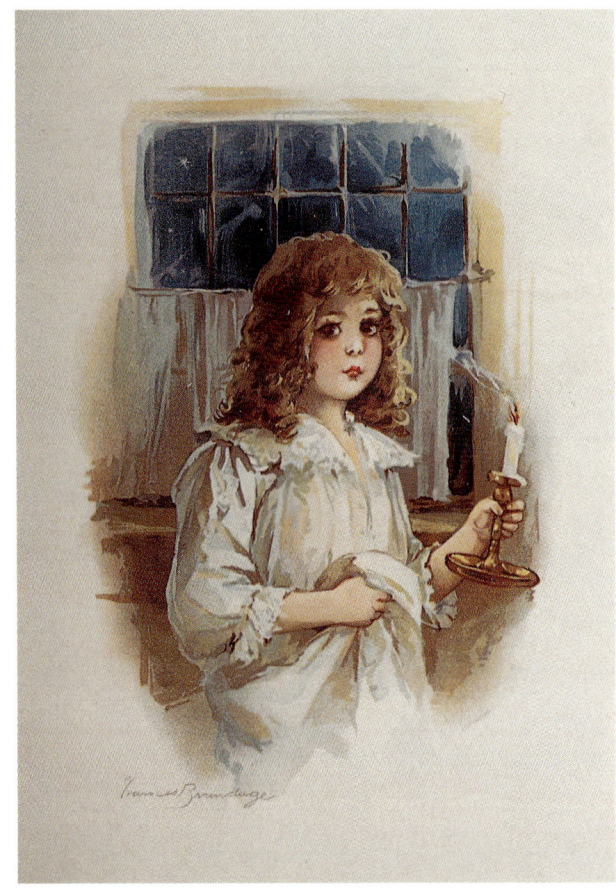
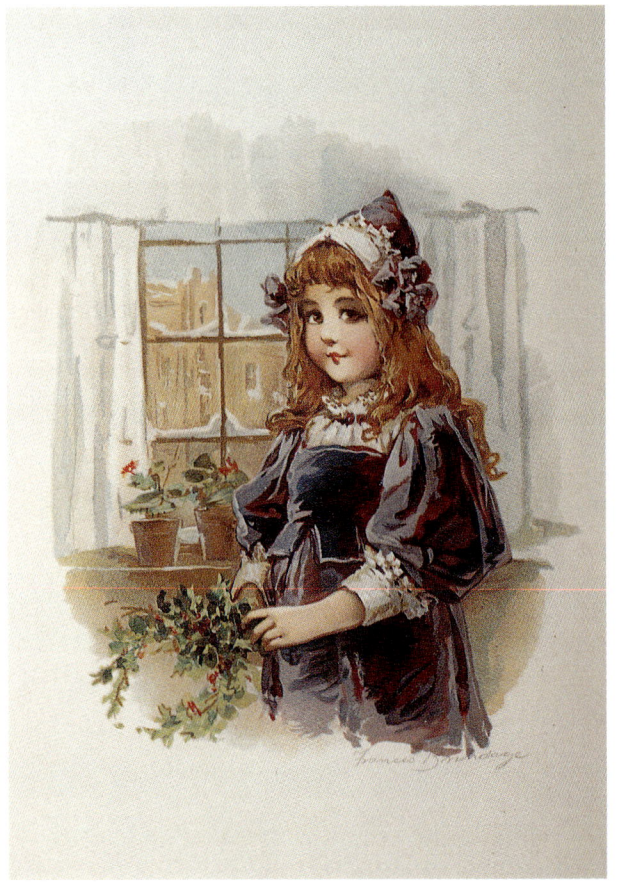
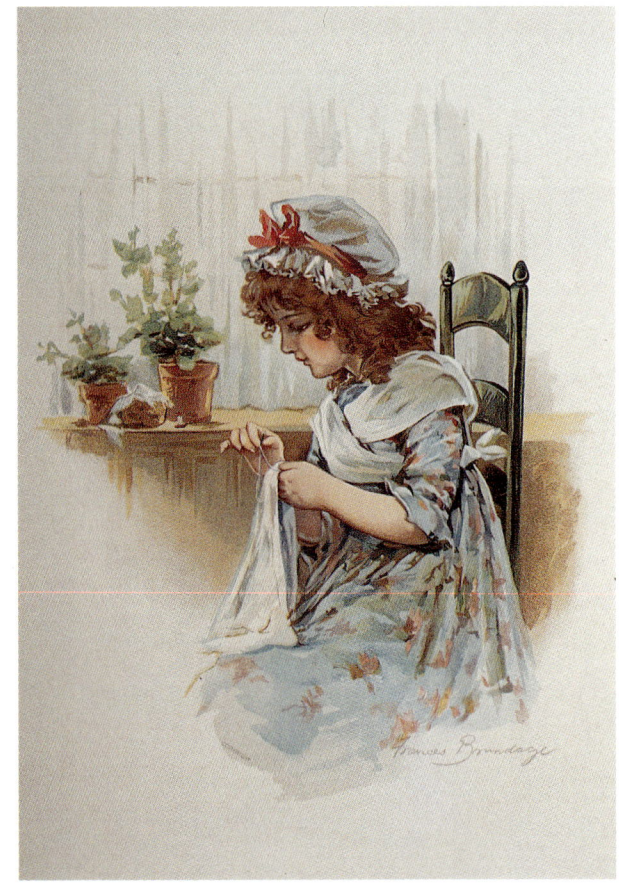

beautiful their dress was to be. Cinderella heard about it—and wanted to go. She begged and pleaded to be allowed to go—but the step-

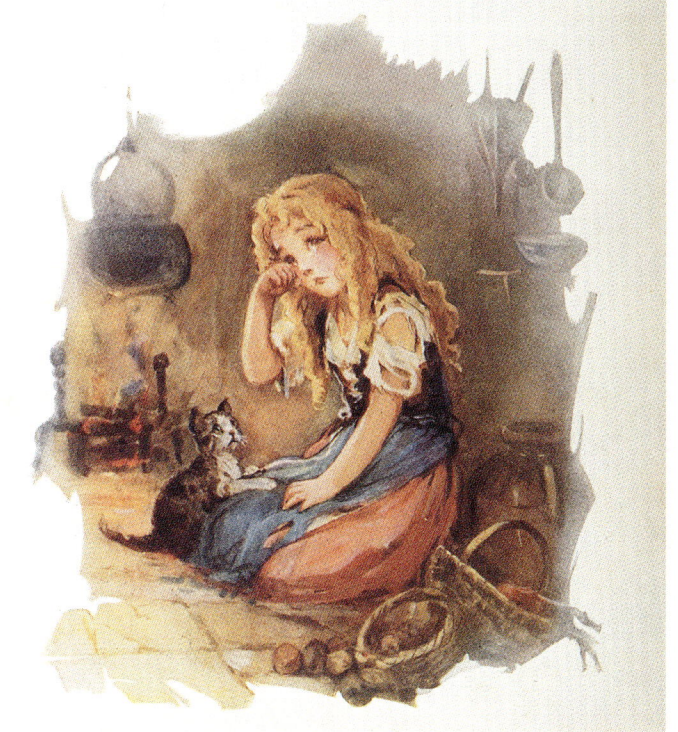

Illustration from *Cinderella* published by Saalfield.

"Goldilocks and the Three Bears" from *Goldilocks* published by Saalfield.

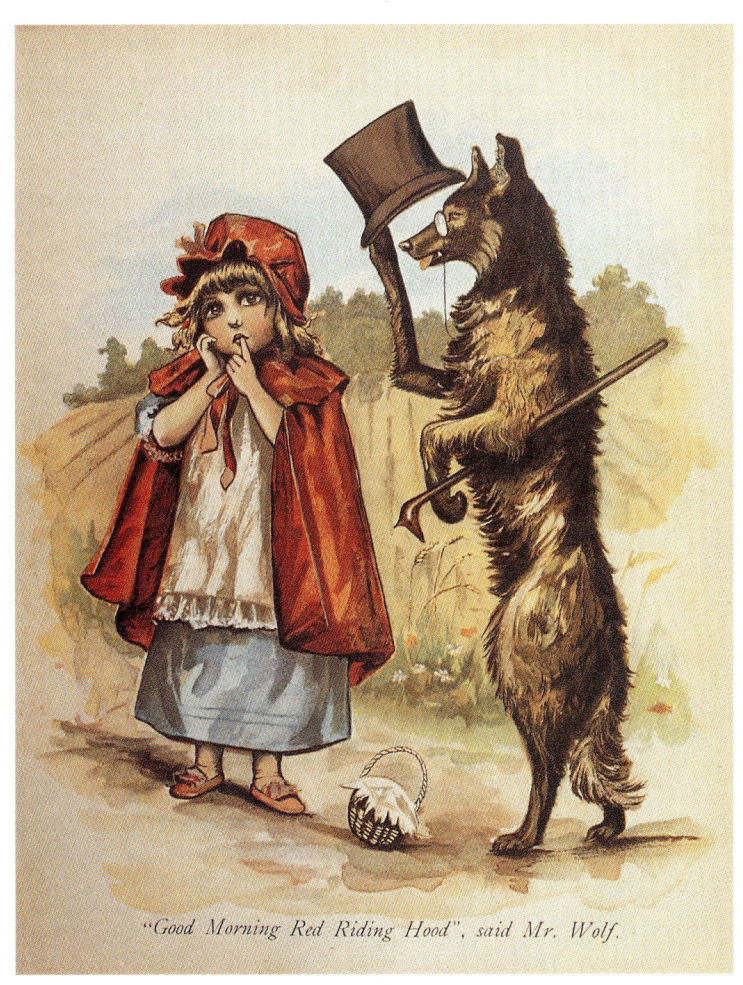

"Red Riding Hood and Mr. Wolf" from *Little Red Riding Hood* published by Raphael Tuck & Sons.

The following illustrations are covers of books illustrated by Frances Brundage. These are just a few of the many wonderful covers.

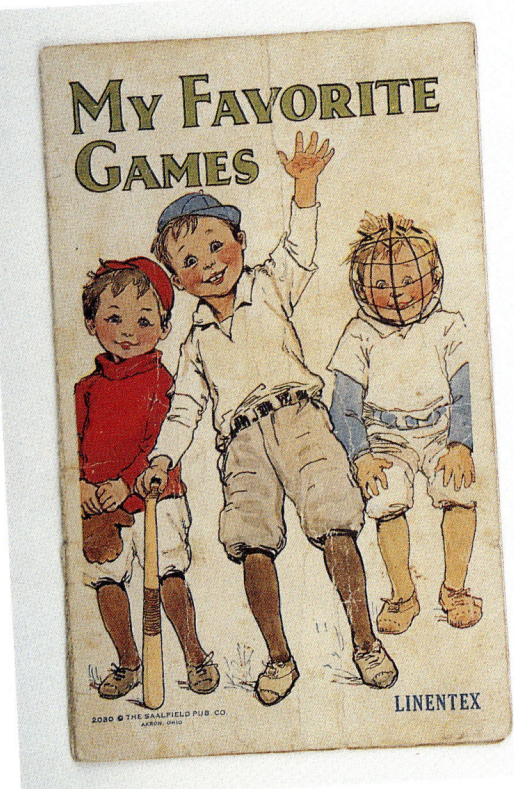

Cover of *My Favorite Games* published by Saalfield.

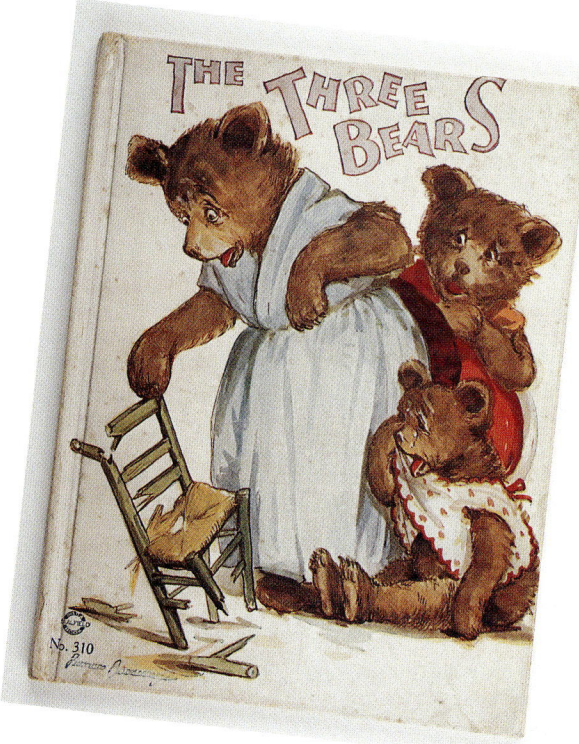

Cover of *The Three Bears* published by Saalfield.

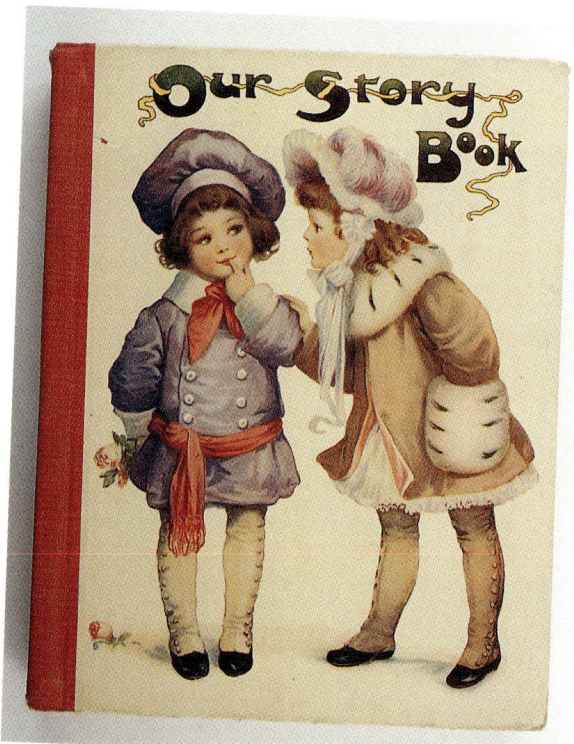

Cover of *Our Story Book* published by Cupples & Leon.

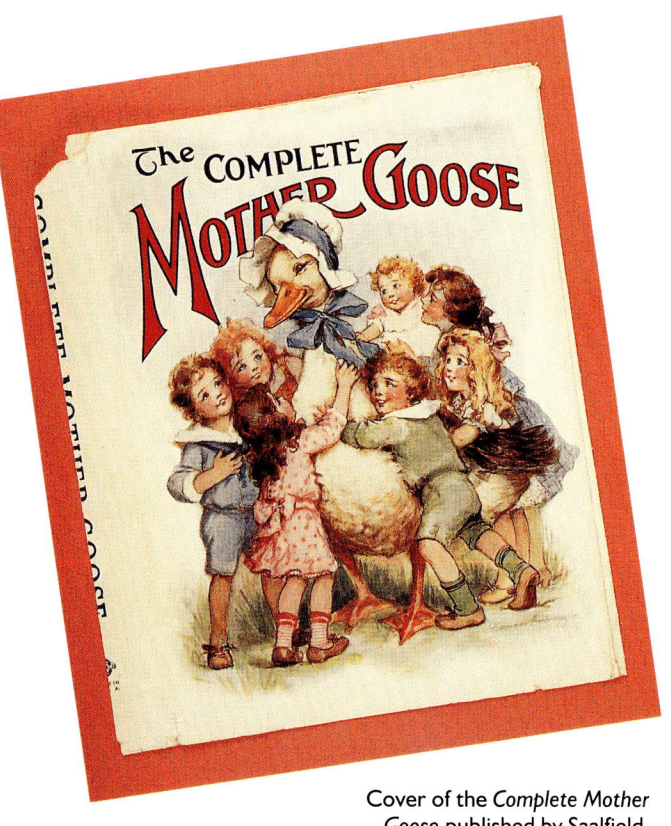

Cover of the *Complete Mother Goose* published by Saalfield.

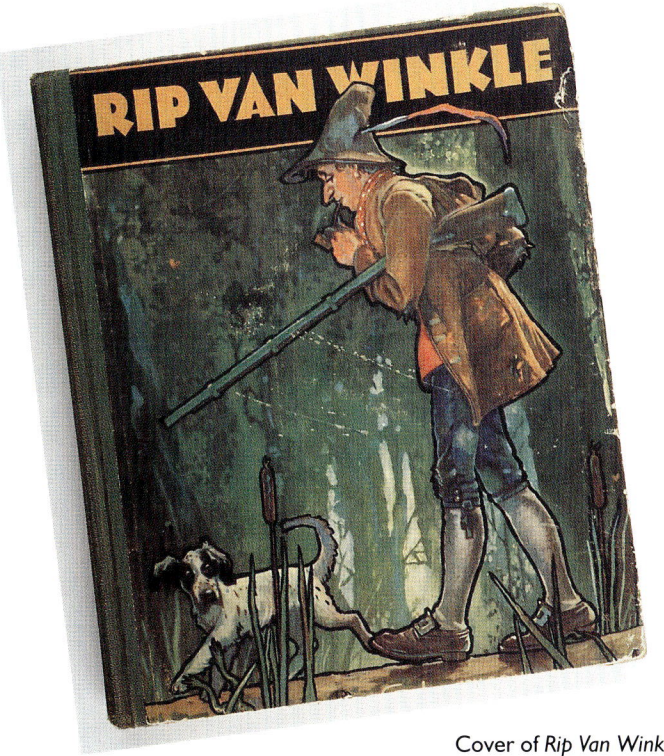

Cover of *Rip Van Winkle* published by Saalfield.

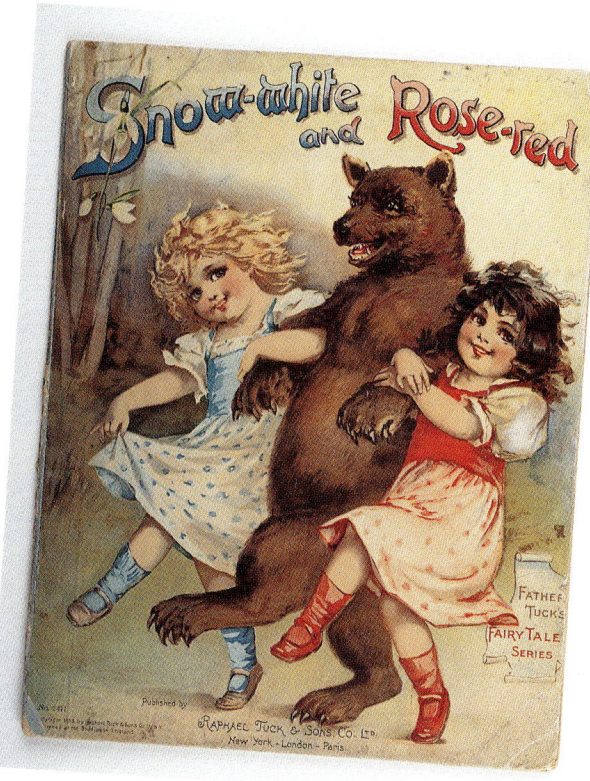

Cover of *Snow-white and Rose-red* published by Raphael Tuck & Sons.

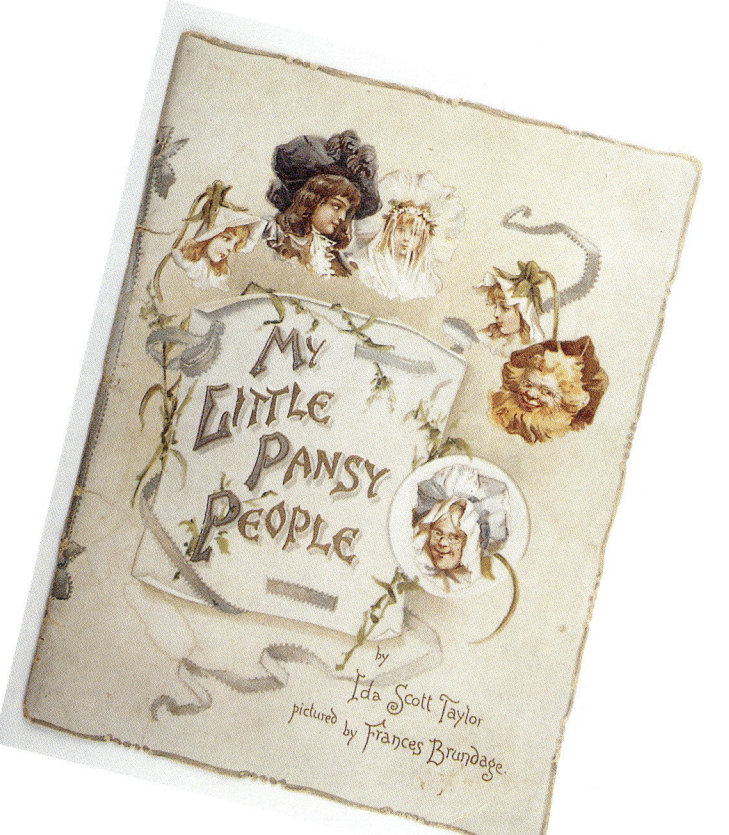

Cover of *My Little Pansy People* published by Raphael Tuck & Sons.

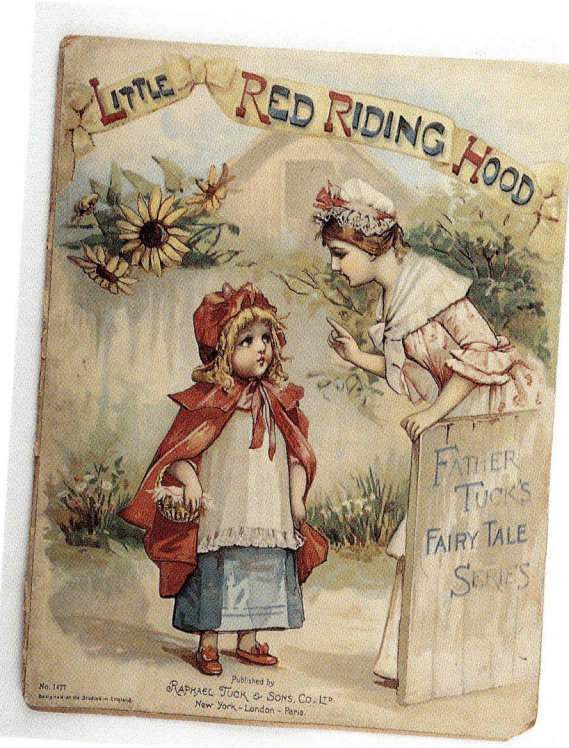

Cover of *Little Red Riding Hood* published by Raphael Tuck & Sons.

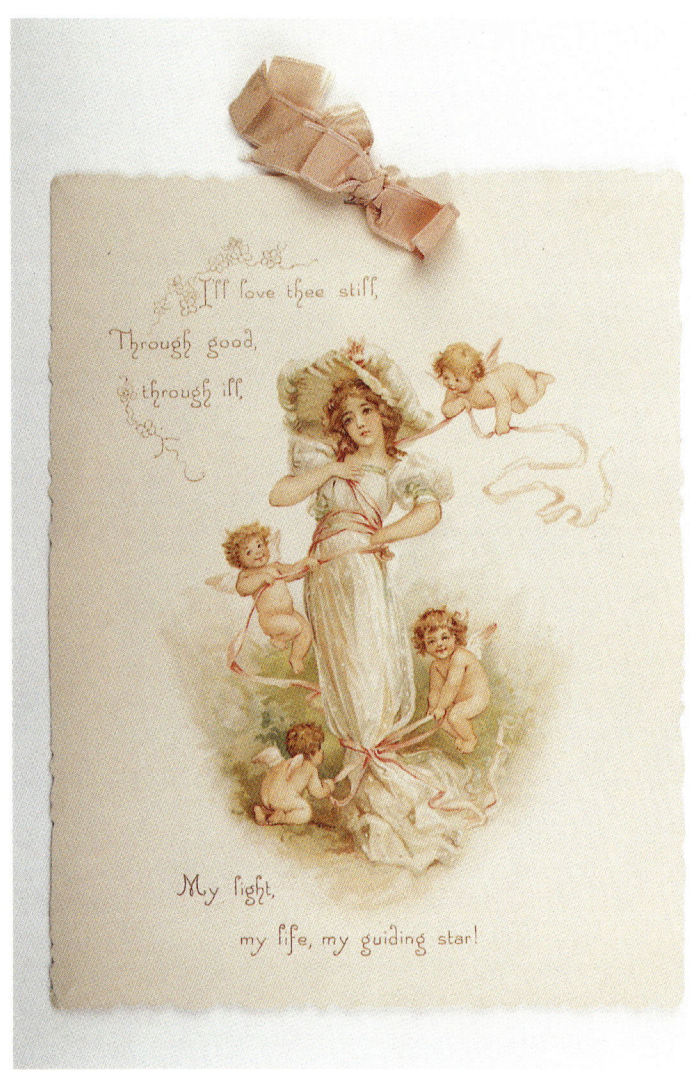

"Young Woman and Cherubs" from *Love Holds the Reins* published by Raphael Tuck & Sons.

Illustration from *Love Holds the Reins* published by Raphael Tuck & Sons.

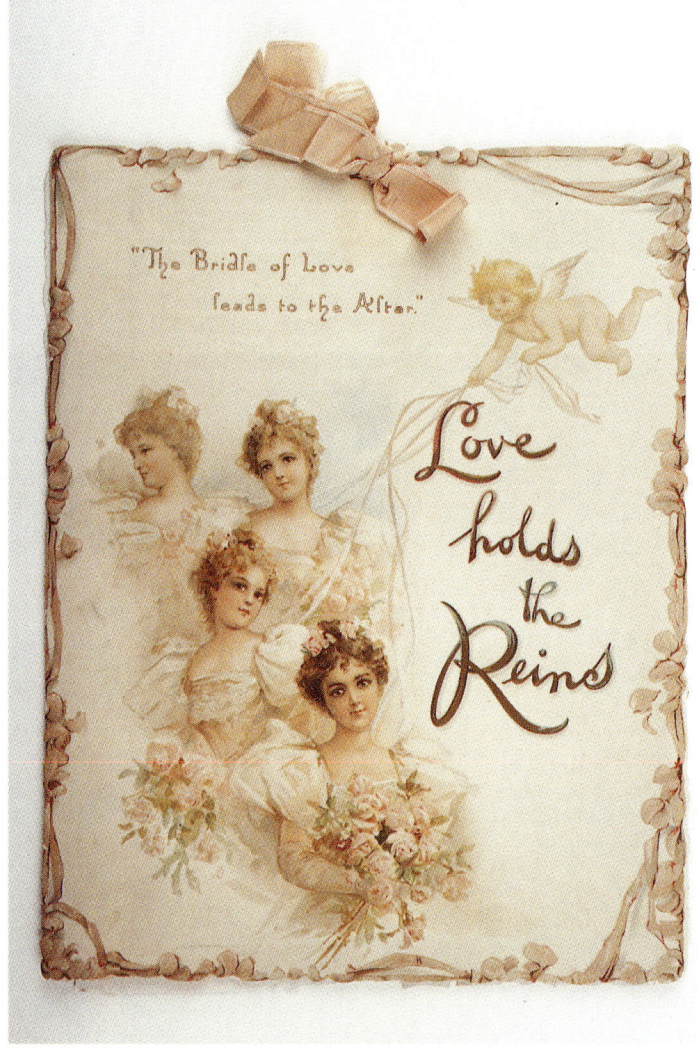

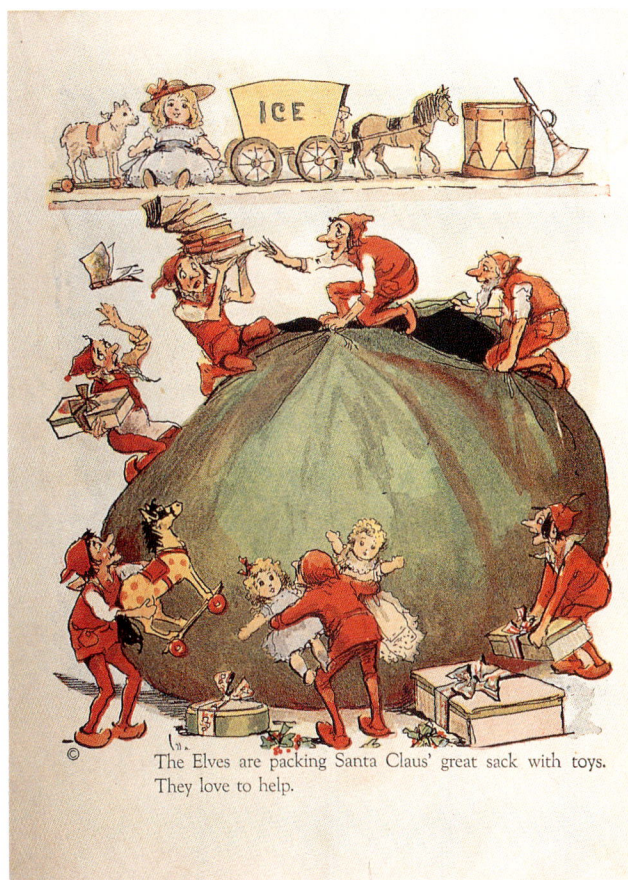

"Santa's Elves" from *Dear Old Santa Claus*
published by Charles E. Graham & Co.

"Santa" from *Dear Old Santa Claus*
published by Charles E. Graham & Co.

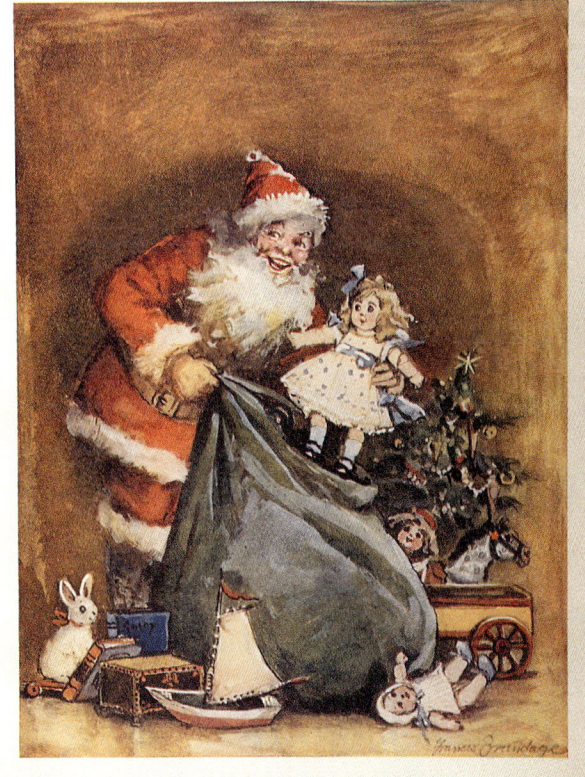

Left:
Cover of *Father Christmas* published by Raphael Tuck & Sons.

Right:
Illustration from *The Night Before Christmas* published by Saalfield.

Illustrations from *Childhood* published by Charles E. Graham.

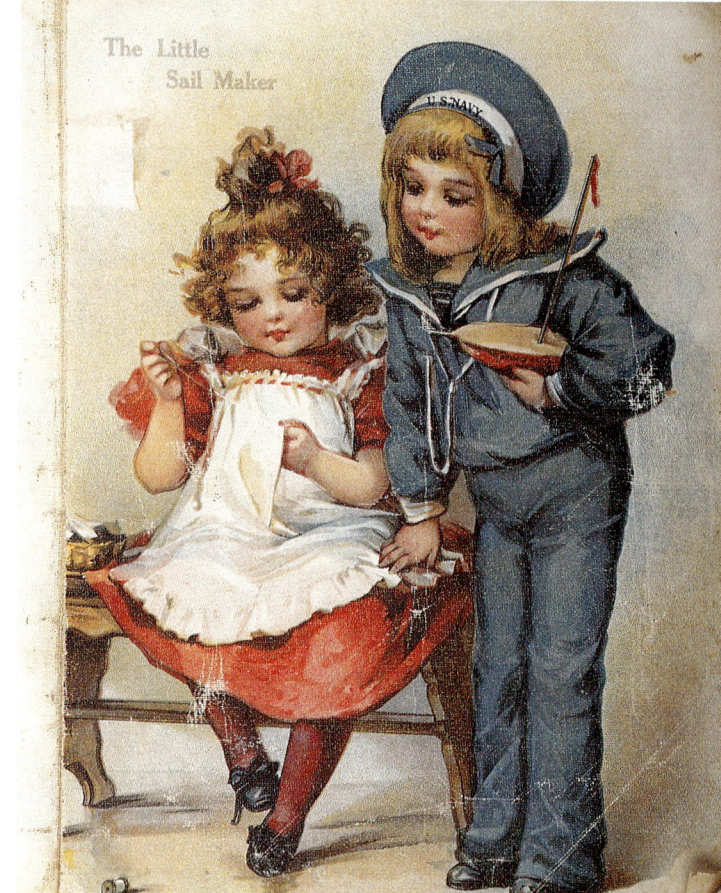

This is a beautiful cloth book.

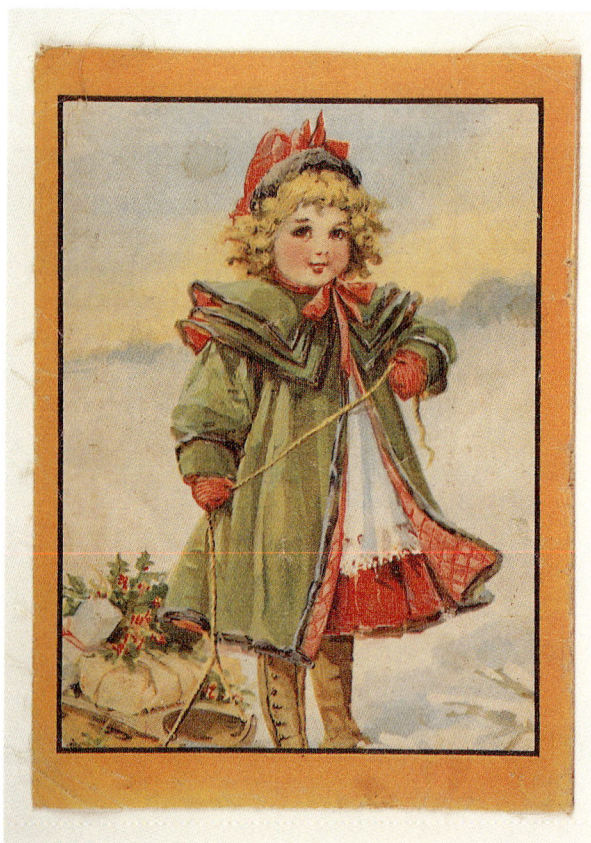

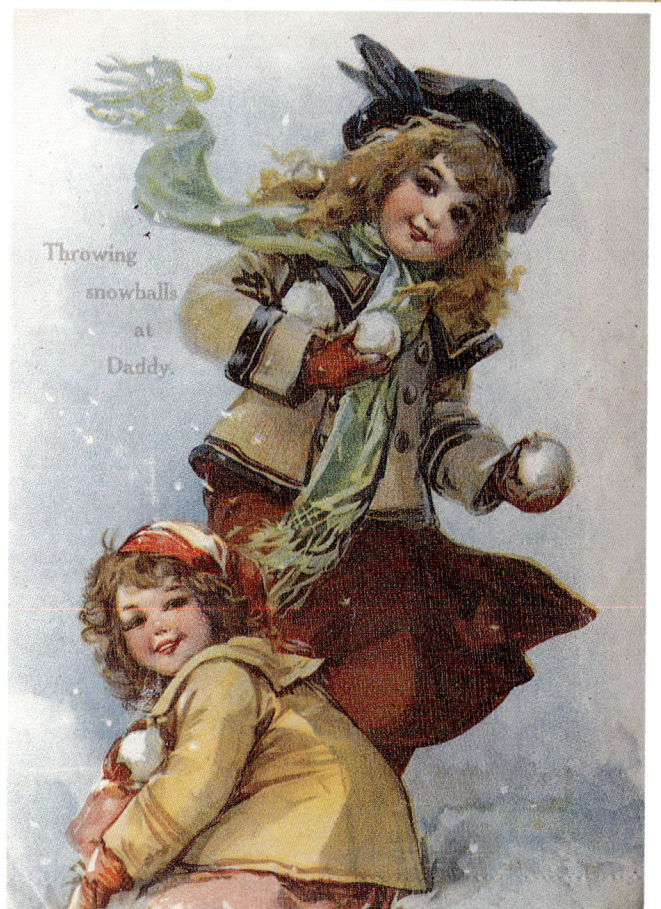

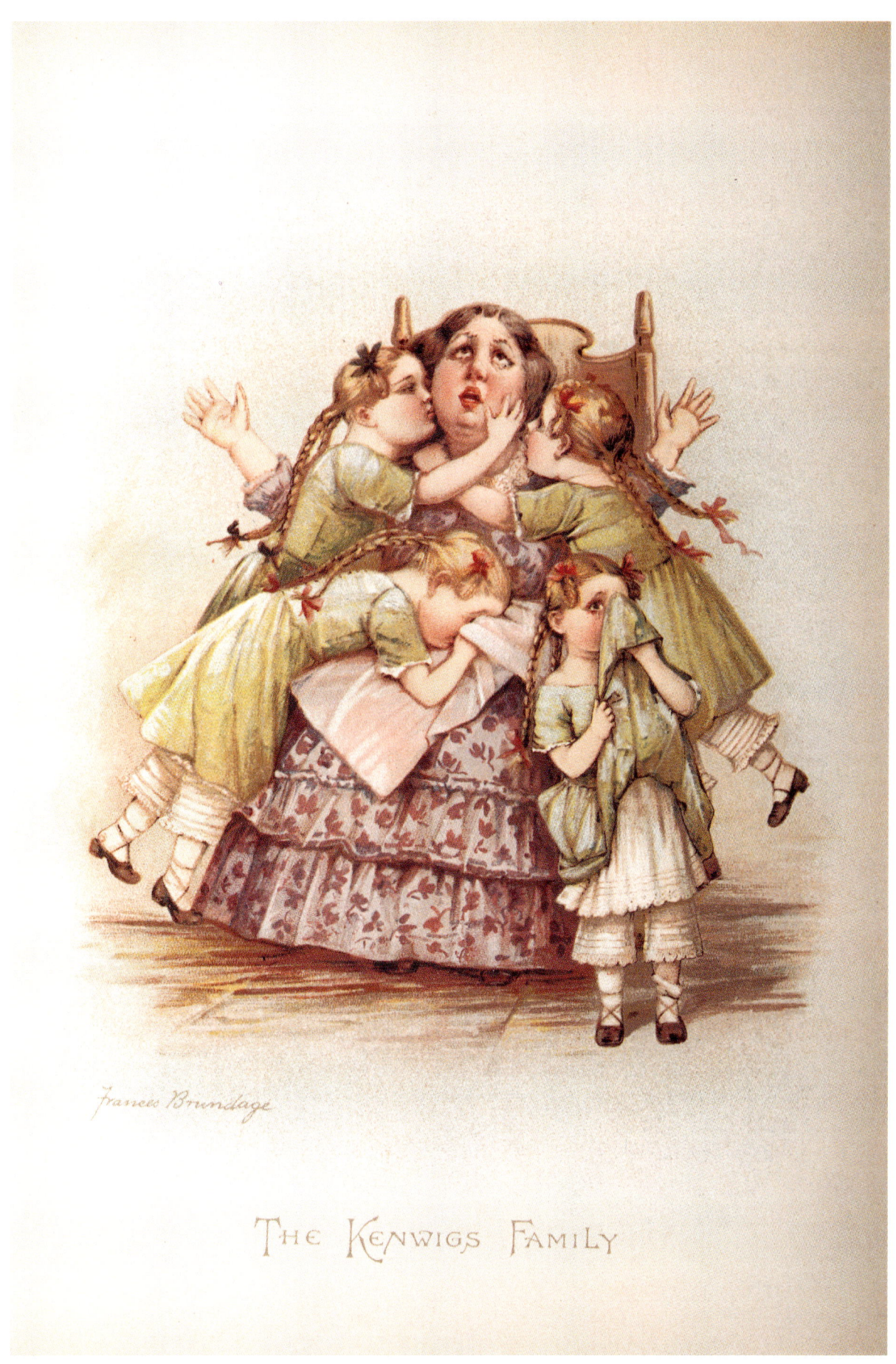

"The Kenwigs Family" from *Children's Stories from Dickens* published by Raphael Tuck & Sons.

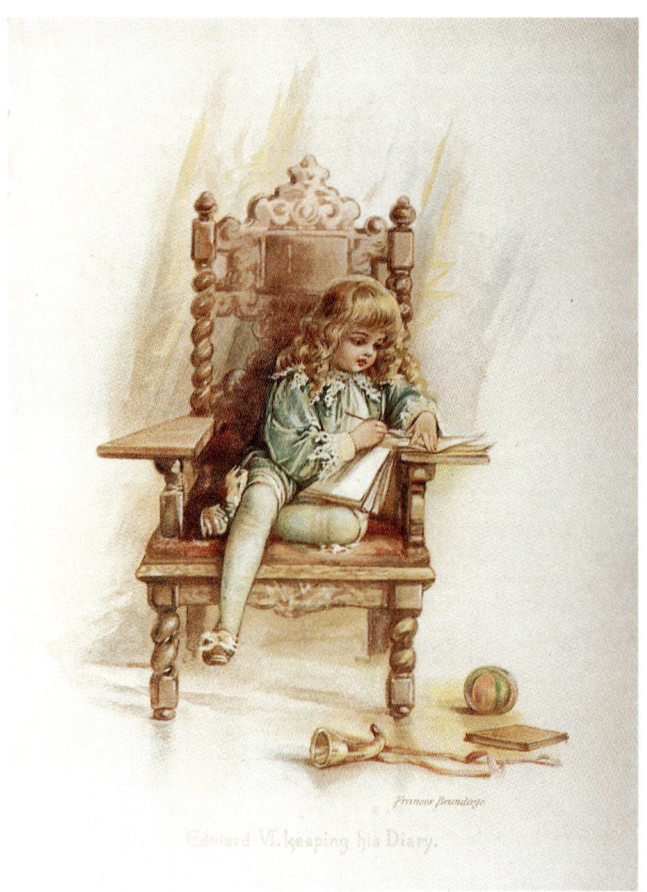

"Edward VI" from *Royal Children of English History* published by Raphael Tuck & Sons.

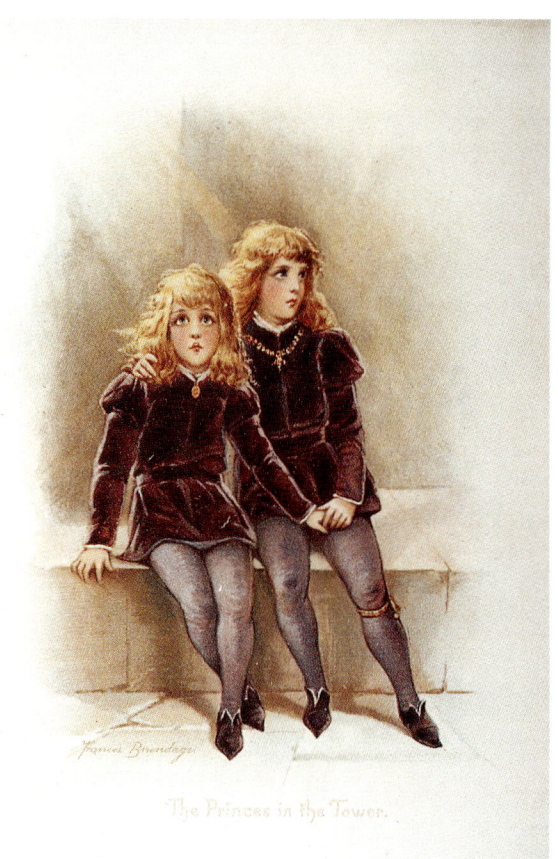

"The Princes in the Towers" from *Royal Children of English History* published by Raphael Tuck & Sons.

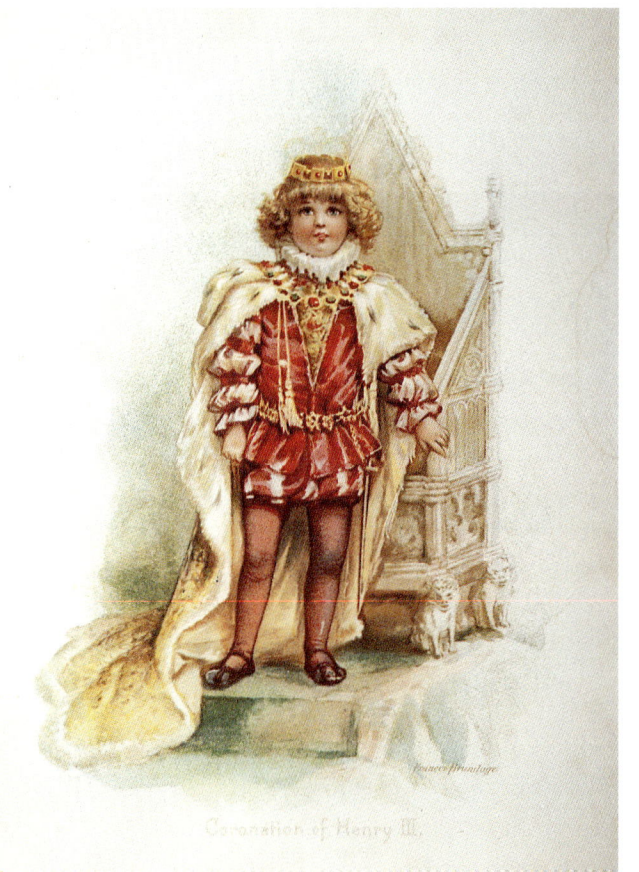

"Coronation of Henry III" from *Royal Children of English History* published by Raphael Tuck & Sons.

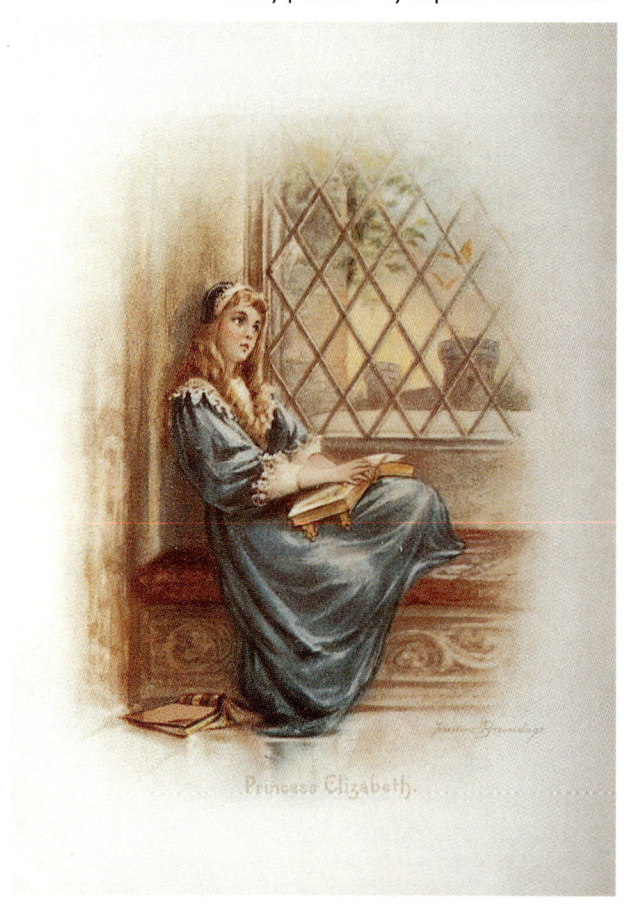

"Princess Elizabeth" from *Royal Children of English History* published by Raphael Tuck & Sons.

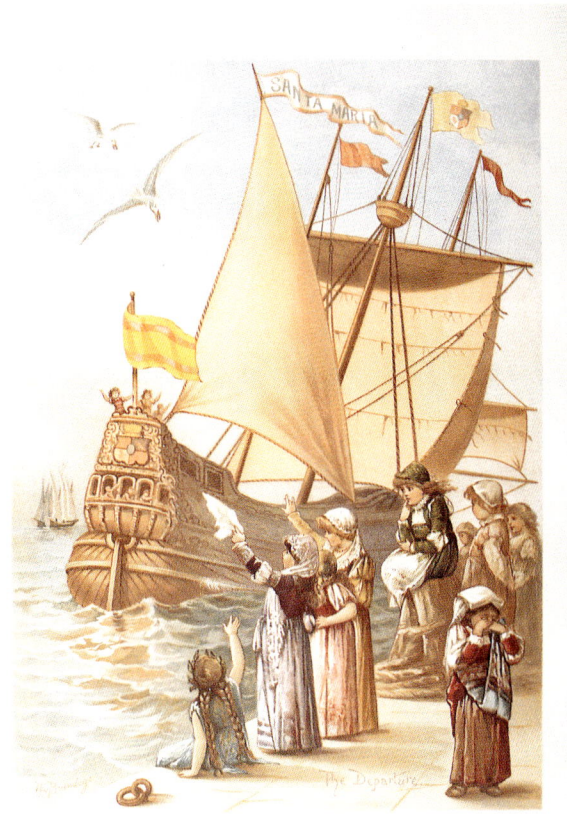

"The Departure" from *The Story of Columbus* published by Raphael Tuck & Sons.

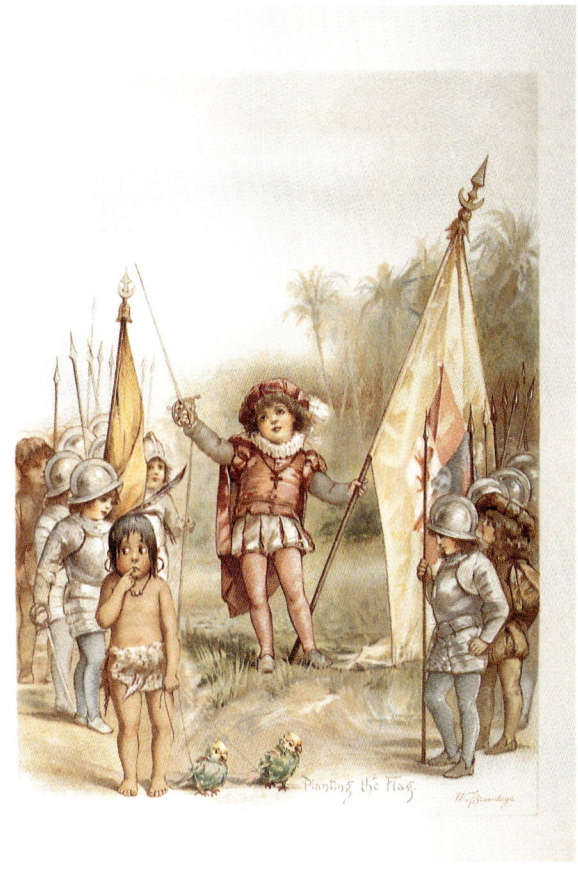

"Planting the Flag" from *The Story of Columbus* published by Raphael Tuck & Sons.

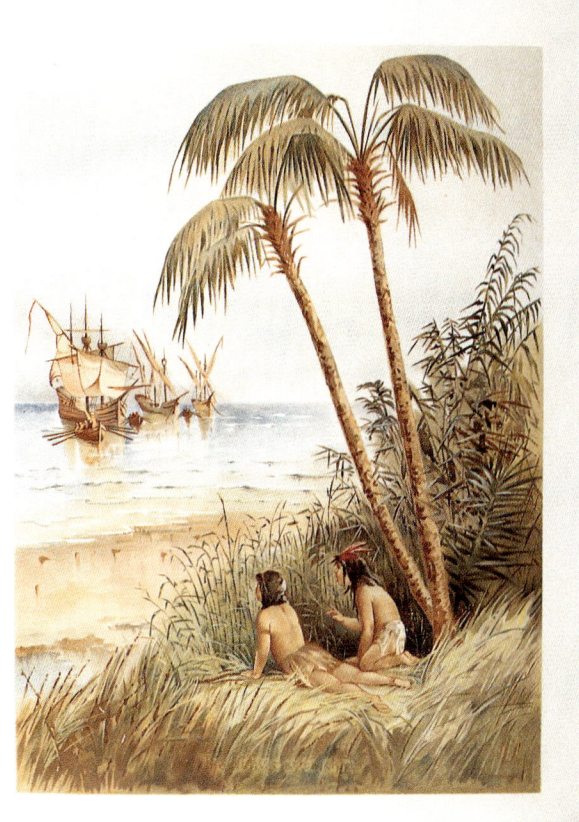

"The Natives Astonished" from *The Story of Columbus* published by Raphael Tuck & Sons.

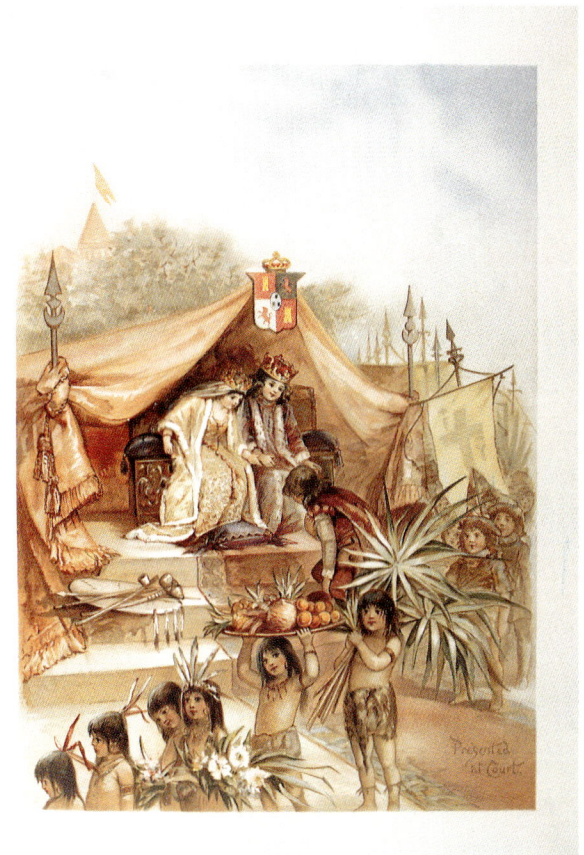

"Presented at Court" from *The Story of Columbus* published by Raphael Tuck & Sons.

31

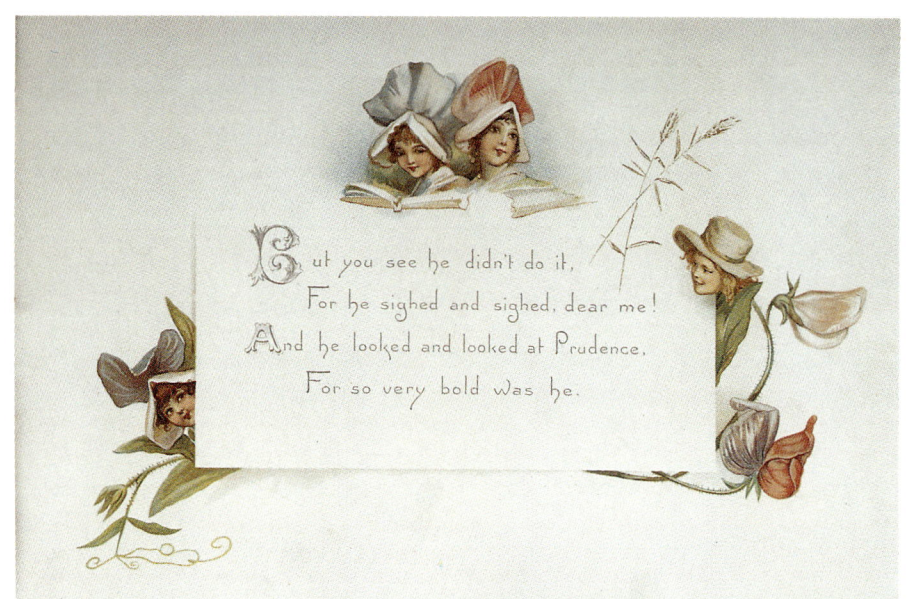

Left and below:
Illustrations from *A Little Quaker Meeting* published by Raphael Tuck & Sons.

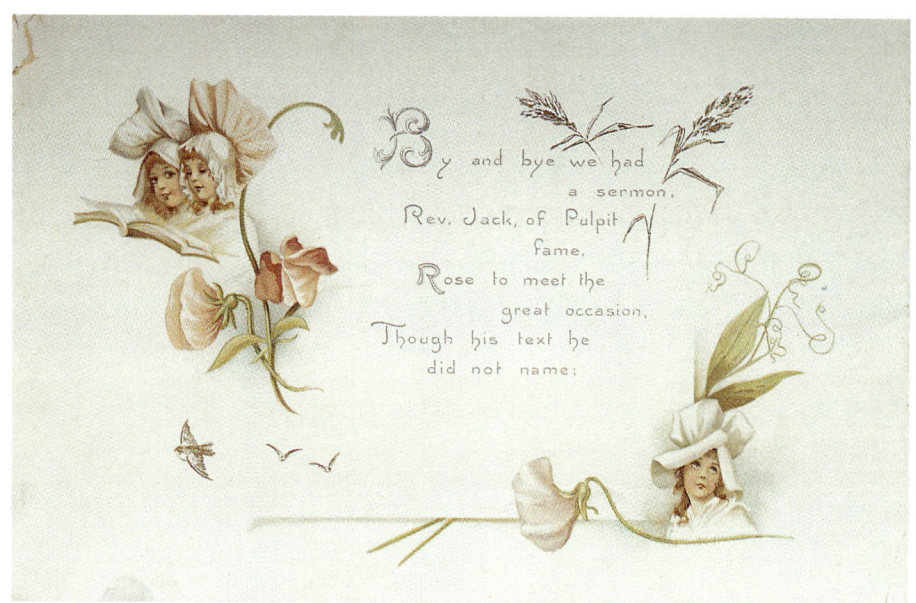

Below and below right:
Illustrations from *My Little Pansy People* published by Raphael Tuck & Sons.

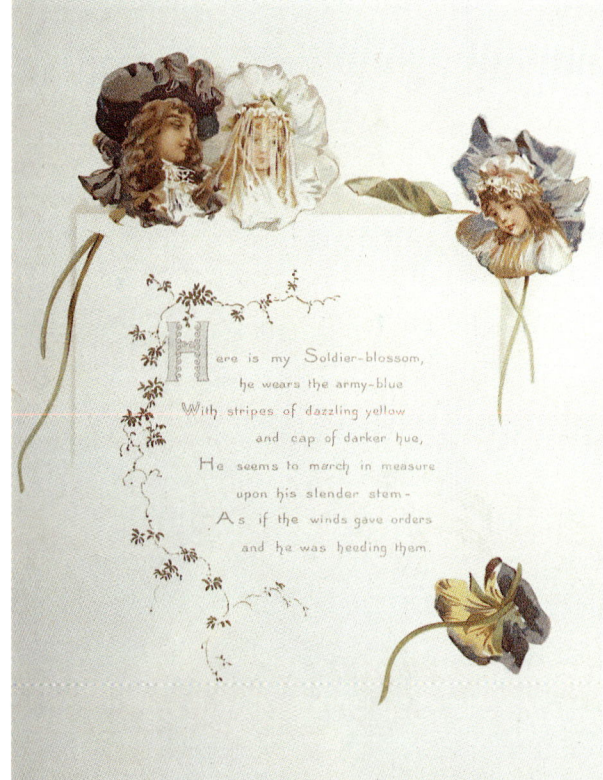

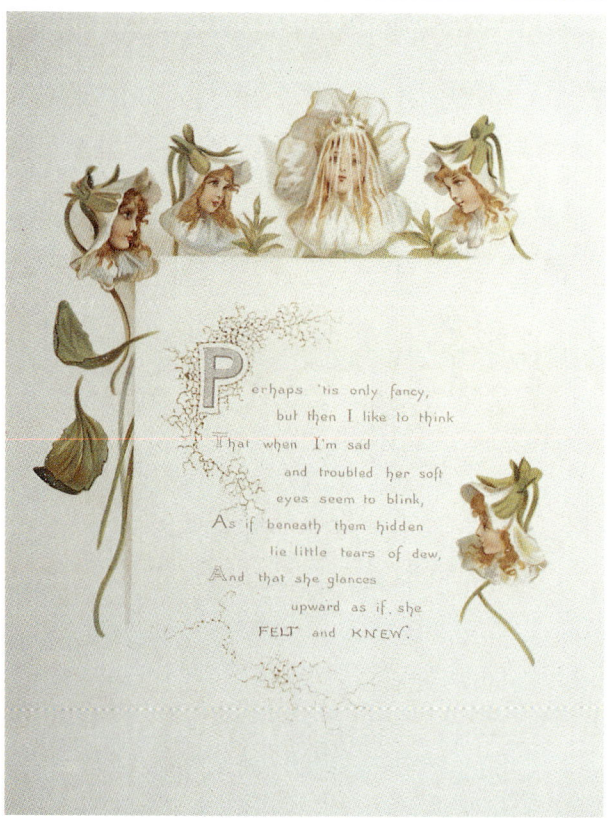

Illustrations from *Our Wedding* published by Raphael Tuck & Sons.

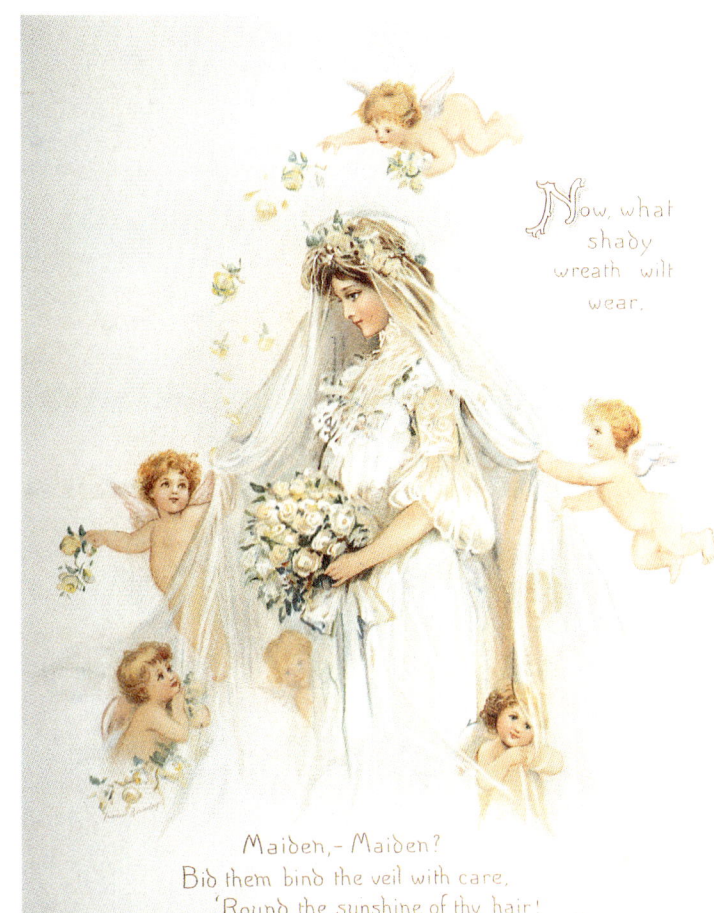

Now, what shady wreath wilt wear.

Maiden, – Maiden?
Bid them bind the veil with care,
'Round the sunshine of thy hair!

Barry Cornwall

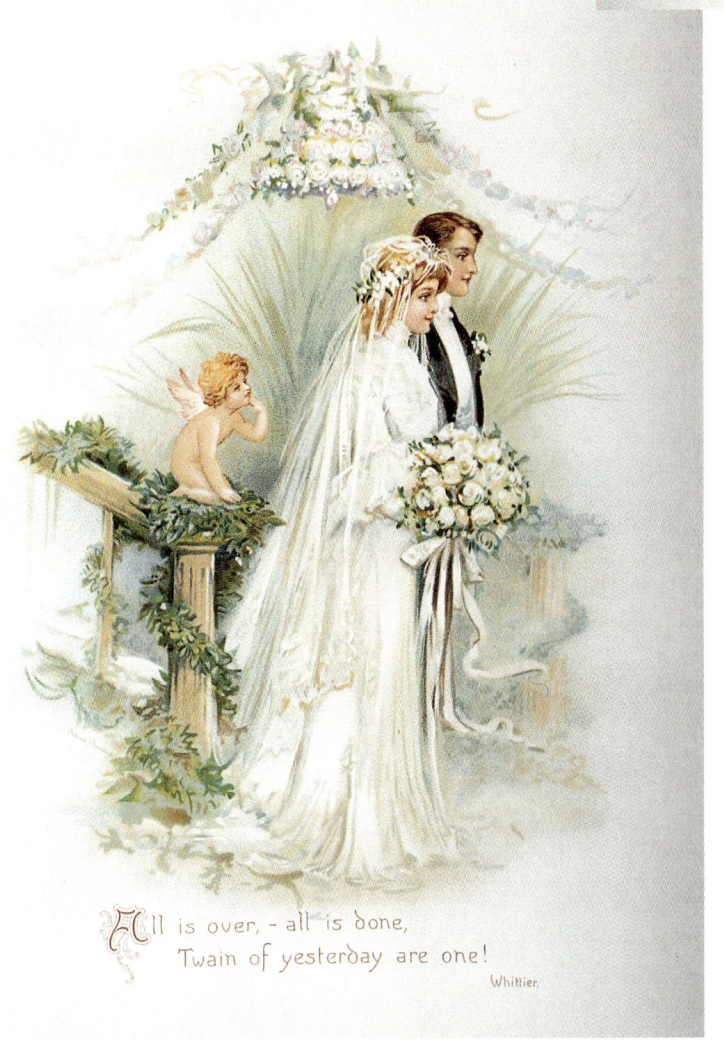

All is over, – all is done,
Twain of yesterday are one!

Whittier

The following eight illustrations are from *Little Darling's Birthday Book* published by Raphael Tuck & Sons.

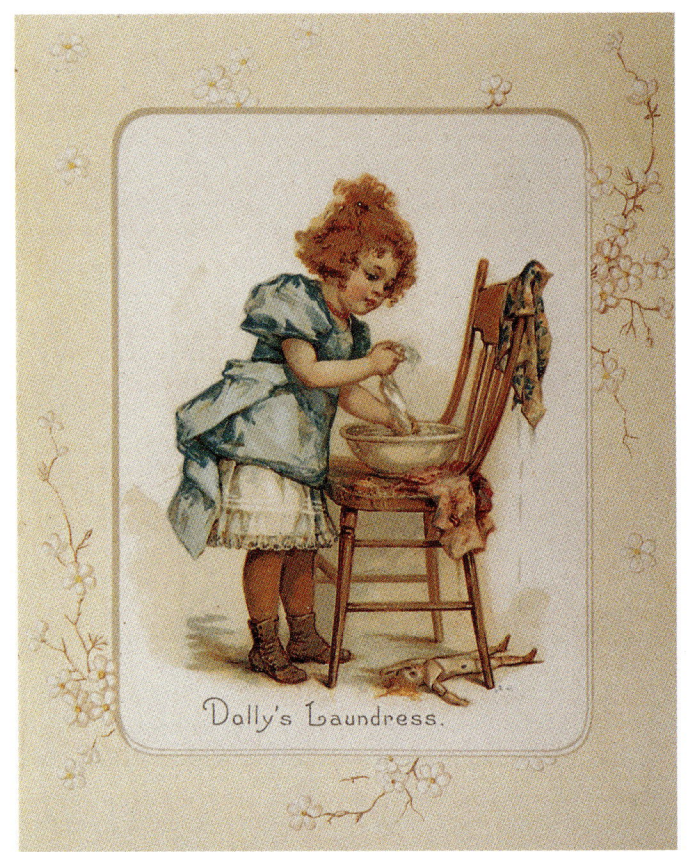
Dolly's Laundress.

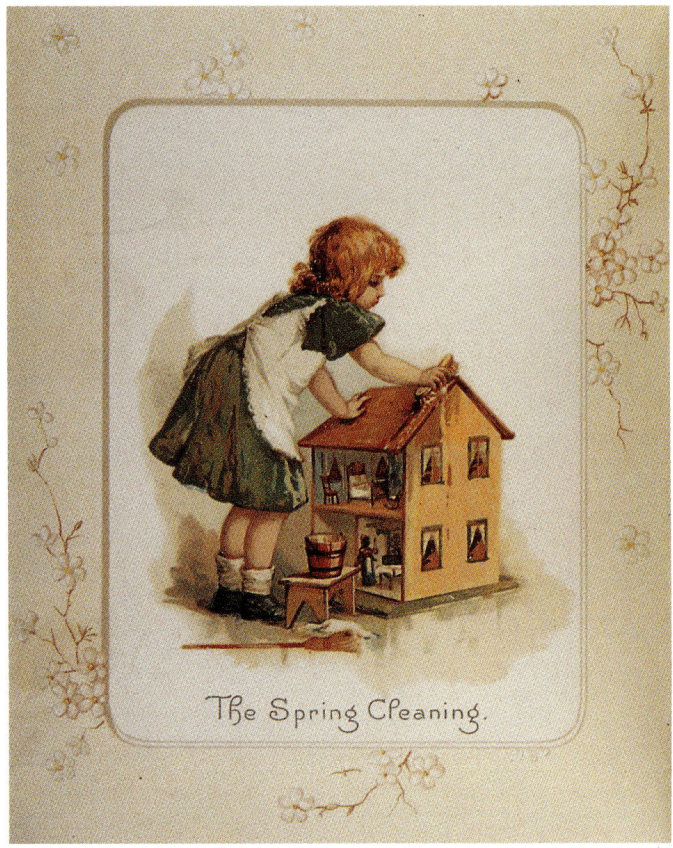
The Spring Cleaning.

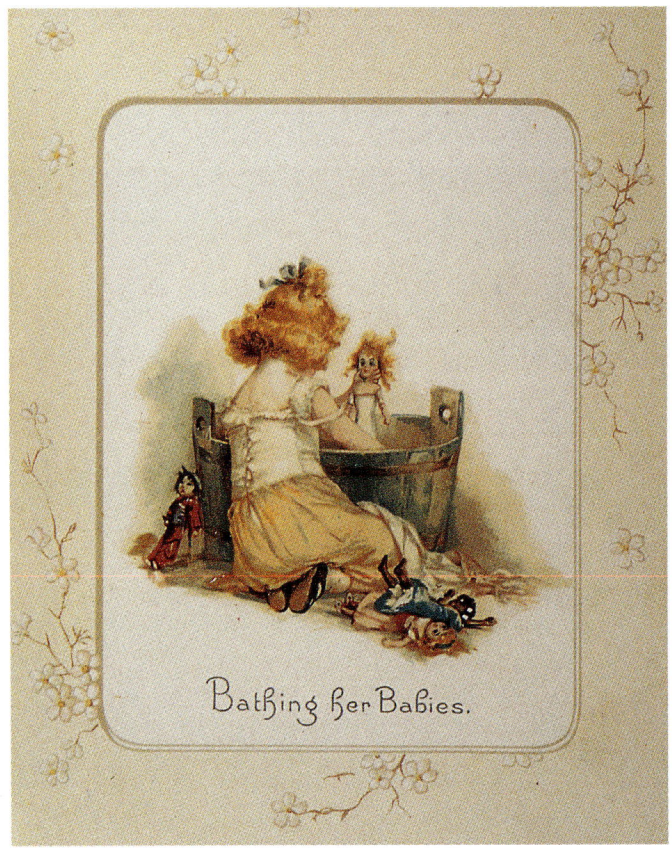
Bathing her Babies.

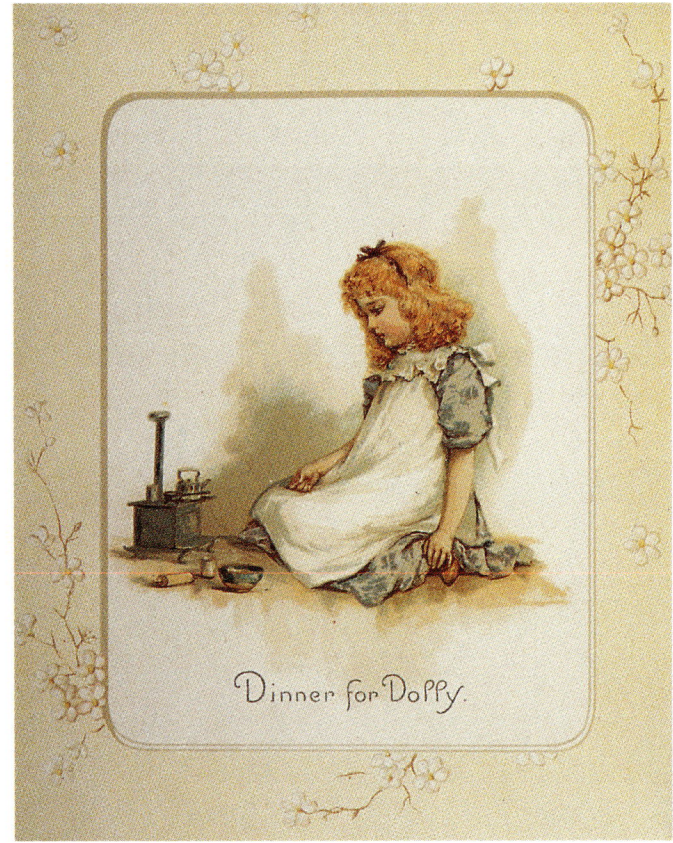
Dinner for Dolly.

Ready to Start.

Daydreams.

Many Happy Returns.

Helping Mother.

Illustrations from *Our Baby's History* published by Ernest Nister and E. P. Dutton & Co.

Head of flaxen ringlets;

Eyes of Heaven's blue;

Parted mouth—
a rosebud—

Pearls just peeping through.

Left and below:
Illustration from *Our Baby* published by Raphael Tuck & Sons. (blue cover)

THE BATH.

Only a golden head,
 Curly and soft;
Only a tongue that wags
 Loudly and oft.

Only a tender flower,
 Sent us to rear,
Only a life to love
 While we are here.

Illustration from *Baby's Book*
published by Raphael Tuck & Sons.

37

Illustrations from *Our Baby* published by Raphael Tuck & Sons (white cover).

First Word

was
It was spoken
day of
in the year
when Baby was
old.

Only a tender flower
Sent us to rear,
Only a life to love
While we are here.

Only a baby small
Never at rest;
Small, but how dear to us
God knoweth best.

Only two cherry lips,
One chubby nose;
Only two little hands,
Ten little toes.

Only a golden head,
Curly and soft;
Only a tongue that wags
Loudly and oft.

38

Illustrations are from *Love's Greetings* published by Boston, DeWolfe, Fiske.

Illustrations are from *Daughters of Colonial Days* published by Boston, DeWolfe, Fiske.

Illustrations are from *When I Grow Up* published by Samuel Gabriel Sons & Co.

"Play Ball!"

Illustrations are from *Father Tuck's Annual* published by Raphael Tuck & Sons.

Chapter Two
Trade Cards

In the late 1800s and early 1900s, colorfully illustrated trade cards were traditionally used by businesses as gifts and advertisements. Many were chromolithographs.

This section shows several trade card sets that are attributed to Brundage. The Woolson Spice Christmas trade cards and Easter trade cards, pictured, are probably from sets of 12. There are other sets not shown in their entirety, such as the 48-card set of Arbuckle Bros. Coffee cards.

An unsigned advertising trade card for Edwardsburg Table Syrup. (3 3/4" x 5 1/4") ($15-25)

These ten illustrations on this page and next two pages are from unsigned Christmas trade cards for Woolson Spice Company, Toledo, Ohio & Kansas City, Mo., copyright 1893. Gast Lith. Co., New York & Chicago. (5 1/2" x 7") and (7" x 5 1/2") ($15-25)

Woolson Spice trade card.

Woolson Spice trade cards.

Woolson Spice trade cards.

Woolson Spice trade cards.

These seven Illustrations on this page and the next page are from unsigned Easter trade cards for Woolson Spice Company, Toledo, Ohio, copyright 1894. Gast Lith. Co., New York & Chicago. (5 1/4" x 7") and (7" x 5 1/4") ($15-25)

45

Woolson Spice trade cards.

"BABY'S FIRST EASTER"
SEE PREMIUM OFFER ON OTHER SIDE.

SEE PREMIUM OFFER ON OTHER SIDE.

THE WOOLSON SPICE COMPANY'S EASTER GREETING.

Unsigned advertising trade cards for a Belgian tailor.(2 3/4" x 4 1/4") ($25-50)

Unsigned advertising trade cards for Glenwood Ranges. (4" x 5 1/4") ($25-35)

48

GLENWOOD RANGES
MAKE COOKING EASY

Glenwood Ranges
Make Cooking Easy.

Glenwood Ranges
Make Cooking Easy.

Glenwood Ranges
Make Cooking Easy.

Glenwood Range
Make Cooking Easy

An unsigned advertising trade card for Blount Plow Works. (5 1/2" x 3 1/2") ($25-50)

An unsigned advertising trade card for Thomson & Taylor Spice Co. (4 1/2" x 6 1/2") ($25-35)

Two unsigned advertisements for Braggs Candies, Kaufmann & Strauss, N.Y. (3" x 5 1/2") ($15-25)

Unsigned advertising trade cards for Home Insurance Co. of N.Y.

(3 1/2" x 5 1/2") ($10-15)

(3 1/2" x 5 1/2") ($10-15)

(3 1/2" x 5 1/2") ($10-15)

(5 1/2" x 4") ($10-15)

51

An unsigned advertising trade card for Home Insurance Co. of N.Y. (3 1/2" x 5 1/2") ($10-15)

Two unsigned advertising trade cards for Gold Band Coffee, Thomson & Taylor Spice Co., Chicago.

(5 1/4" x 4 1/4") ($15-25)

(6 1/2" x 4 1/2") ($15-25)

52

An unsigned advertising trade card for *Radway's Pills*, Radway & Co., N.Y., copyright 1890, Donaldson Brothers, N.Y. This illustration is the same as below in black and white and signed for *Harper's Young People*. (3" x 4 1/2") ($15-25)

A black and white signed illustration for *Harper's Young People*, published by Harper & Brothers, New York, dated April 10, 1888. Image used above in advertising trade card. ($15-25)

The following illustrations are unsigned, embossed, die-cut, trade cards for Glenwood Ranges. (3 1/2" x 6") ($25-40)

54

An unsigned trade card for Hood's Sarsaparilla, copyright 1891 by Hood & Co. (5 1/2" x 2 3/4") ($15-20)

An unsigned trade card for Malena Stomack Liver Pills, Malena Co., Warriorsmark, Pa. This was also a signed print from the book *Hours In Many Lands*. (5" x 7") ($15-20)

An unsigned trade card for Everett Piano. (3 1/4" x 4 3//4") ($5-10)

An unsigned trade card for Everett Piano. (3 1/4" x 4 3/4") ($5-10)

55

These three unsigned advertising trade cards are for Arbuckle Brothers Coffee, N.Y., N.Y., copyright 1893, and give a pictorial history of sports and pastimes of nations. (set of 48) (5" x 3") ($3-5)

56

Unsigned advertising trade cards for John Hancock Mutual Life
Insurance Co., Boston, Mass. (3 1/2" x 4 1/2") ($15-20)

This image is also a signed book print
from *The Children's Gallery*.

57

Chapter Three
Valentines

Numerous valentines are attributed to Frances Brundage. Most Brundage valentines are unsigned, but there are so many signed illustrations in books and prints showing her various styles that most valentines are easily identified; often by the eyes of the beautiful children. Other identifying factors are the publishing company and date of the valentine, since we know approximately when she illustrated for different companies.

The valentine fans are the rarest and most expensive of the valentines. They are seldom offered for sale at paper shows. There are many fan collectors, which probably accounts for the scarcity of Brundage fans for sale.

Museum displays of antique paper valentines are often filled with unsigned and unrecognized images by Brundage. Perhaps this book will help give proper credit and recognition to Frances Brundage for her many contributions in beautiful artwork.

A mechanical die-cut valentine, Samuel Gabriel & Sons. (4" x 6 3/4") ($15-25)

A mechanical die-cut valentine, Samuel Gabriel & Sons. (3 1/2" x 6 3/4") ($15-25)

A mechanical, embossed, die-cut valentine, Raphael Tuck & Sons. (Restored) Brundage's version of Outcault's "Buster Brown". (9 1/2" x 13") ($100-200)

A mechanical, embossed, die-cut valentine, Raphael Tuck & Sons. (7 1/2" x 12 1/2") ($100-200)

A mechanical, embossed, die-cut valentine. (8" x 12 1/4") ($100-200)

A mechanical, embossed, die-cut valentine. (7 1/2" x 14") ($100-200)

An embossed, die-cut, fold-out three-dimensional valentine. (9 1/2" x 10") ($150-200)

An embossed, die-cut, fold-out three-dimensional valentine with paper honeycomb. (8 1/2" x 8 1/2") ($150-200)

Embossed, folding, die-cut valentines. (7 1/4" x 6 3/4") ($25-35)

An embossed, die-cut, basket fold-out valentine with easel backing, Raphael Tuck & Sons. (4 1/2" x 9 1/2") ($75-125)

An embossed, die-cut, basket fold-out valentine, Raphael Tuck & Sons. (5 1/2" x 9 1/2") ($75-125)

An embossed, die-cut, package fold-out valentine with easel backing by Raphael Tuck & Sons. (4 1/2" x 9 1/4") ($125-250)

61

An embossed, die-cut, fold-out package valentine, Raphael Tuck & Sons. (5 1/4" x 8") ($75-125)

An embossed, die-cut, car front fold-out valentine, Raphael Tuck & Sons. (8" x 7 1/2") ($75-125)

An embossed, die-cut, package fold-out valentine with an easel, Raphael Tuck & Sons. (6 1/4" x 9 1/4") ($75-125)

An embossed, die-cut, "pop-up" valentine with easel backing, Raphael Tuck & Sons. (8" x 8 1/2") ($150-200)

An embossed, die-cut, package fold-out valentine with an easel, Raphael Tuck & Sons. (6 1/2" x 9 1/2") ($75-125)

An embossed, die-cut fold-out valentine, Samuel Gabriel & Sons. (7 1/2" x 7") ($75-125)

"To My Sweet Valentine," an embossed, die-cut, valentine fan. (12 1/2" x 7 1/2") ($300-500)

"Yes I do!," an embossed, die-cut, valentine fan. (12 1/4" x 8 1/2") ($400-500)

"Little Darlings," an embossed, die-cut valentine fan. (12 1/2" x 7") ($300-500)

64

"To My Sweetheart," an embossed, die-cut valentine fan. (11" x 8 1/2") ($300-500)

An embossed die-cut valentine. (14" x 10") ($200-250)

65

An embossed, die-cut, fold-out valentine with paper honeycomb. This image was used on another valentine shown. (8" x 9") ($100-125)

An embossed, die-cut, fold-out three-dimensional valentine with paper honeycomb. (12" x 7 1/4") ($125-150)

Two embossed, die-cut, ribbon valentines, Raphael Tuck & Sons.

(5 1/2" x 13 1/2") ($125-150)

(3 3/4" x 11") ($125-150)

66

An embossed, die-cut, folding valentine. (5 3/4" x 13") ($150-175)

An embossed, die-cut, folding valentine, Raphael Tuck & Sons. (7 1/2" x 14 1/2") ($125-150)

An embossed die-cut valentine with easel backing. (6" x 8 1/2") ($25-50)

An embossed, die-cut, fold-out three-dimensional valentine. (7 1/4" x 8") ($50-75)

67

An embossed die-cut valentine. (7 1/2" x 7 3/4") ($50-75)

An embossed die-cut valentine with easel backing, Raphael Tuck & Sons (Restored). (5 1/4" x 9 1/4") ($25-50)

An embossed, die-cut, folding valentine, Raphael Tuck & Sons. (20 1/2"X 7") ($75-100)

An embossed die-cut valentine with easel backing, Raphael Tuck & Sons. (5" x 9 1/2") ($25-50)

An embossed, mechanical, die-cut, "jumping" or "stick" valentine, Raphael Tuck & Sons. (6 1/4" x 12") ($200-300)

A mechanical, embossed, die-cut, "jumping" or "stick" valentine, Raphael Tuck & Sons. (6" x 11 1/2") ($200-300)

69

An embossed, die-cut, fold-out three-dimensional valentine. (9" x 10") ($200-300)

An embossed die-cut valentine. (8 1/2" x 5") ($50-75)

An embossed die-cut valentine, Raphael Tuck & Sons. (7 1/2" x 7 1/2") ($125-200)

70

Left and below:
Embossed die-cut valentines with easel backing.

(4" x 6 3/4") ($25-35)

(2 1/2" x 6 1/4") ($20-25)

An embossed die-cut valentine, Raphael Tuck & Sons. (4 1/4" x 9 1/4") ($25-50)

71

An embossed die-cut valentine.
(8" x 8 1/4") ($50-75)

An embossed die-cut valentine, Raphael Tuck & Sons. (8" x 6 1/2") ($40-60)

An embossed, die-cut, basket fold-out valentine, Raphael Tuck & Sons. (8" x 7 1/2") ($75-125)

An embossed, die-cut, fold-out package valentine with easel. (8" x 7 1/2") ($75-125)

An embossed, die-cut, fold-out basket valentine with easel, Raphael Tuck & Sons. (8" x 7 1/2") ($75-125)

A mechanical, embossed, die-cut "climber" valentine, Raphael Tuck & Sons. (Restored) (6 1/2" x 13") ($200-300)

A mechanical, embossed, die-cut "climber" valentine, Raphael Tuck & Sons. (6 1/2" x 13 1/2") ($200-300)

Mechanical, embossed, die-cut "climber" valentines, Raphael Tuck & Sons.

(6" x 14 3/4") ($200-300)

(8 3/4" x 14 1/4") ($200-300)

(6 1/2" x 14 3/4") ($200-300)

74

A parchment ribbon valentine with an embossed die-cut insert. (9 1/2" x 13 1/2") ($75-125)

A parchment valentine with an embossed die-cut insert. (8" x 8 1/2") ($35-50)

A parchment valentine with an embossed die-cut insert. (9" x 7") ($35-50)

75

An embossed die-cut, fold-out three-dimensional valentine. (9 1/2" x 8 3/4") ($75-100)

An embossed, die-cut, ribbon valentine. (7 1/2" x 10 1/2") ($30-50)

An embossed die-cut valentine. (6 1/2" x 7") ($30-50)

An embossed die-cut valentine.
(20 1/4" x 7 1/2") ($200-275)

77

Embossed die-cut valentines, Raphael Tuck & Sons. (5 1/2" x 11") ($100-125)

An embossed die-cut valentine with fold-out flowers, and with easel, Raphael Tuck & Sons. (Restored) (5 1/2" x 9") ($75-125)

An embossed die-cut valentine with fold-out flowers, and with easel, Raphael Tuck & Sons. (5" x 9 1/4") ($75-125)

Embossed, die-cut, fold-out three-dimensional valentines.

(4 1/4" x 7 1/2") ($25-35)

(5 1/2" x 8") ($25-50)

(4" x 7") ($25-35)

(5" x 8") ($25-50)

79

An embossed, die-cut, fold-out three-dimensional valentine with paper honeycomb. (11" x 11") ($150-200)

(2 3/4" x 6 1/2") ($10-15)

Three embossed die-cut valentines.

(3 3/4" x 4 3/4") ($10-15)

(5 3/4" x 5 3/4") ($10-15)

80

An embossed, die-cut, with fold-down hat valentine, Raphael Tuck & Sons. (7" x 6 1/2") ($75-100)

An embossed, die-cut, fold-out three-dimensional valentine. (7" x 9") ($50-75)

An embossed, die-cut, with fold-down bag valentine and easel, Raphael Tuck & Sons. (7" x 9 1/2") ($75-125)

An embossed die-cut valentine with easel. (4 1/2" x 6 3/4") ($25-35)

81

Embossed, die-cut, fold-out three-dimensional valentines.

(7 1/2" x 7 1/2") ($25-50)

(7 1/2" x 7 1/2") ($25-50)

(7" x 9") ($50-75)

82

An embossed die-cut valentine with easel. (19" x 11 1/2") ($200-300)

Chapter Four
Postcards

Postcards by Frances Brundage were produced from the early 1900s to the early 1920s. In that era, colorful postcards were used much as we use note cards today. The postcards often came in sets of 4, 5, 6, 10, or 12. They were published by a number of companies, including Raphael Tuck & Sons, Samuel Gabriel & Sons, H. I. Robbins, Theo. Stroefer, Nister, and Wexel & Naumann.

Many of the images in books such as *Our Baby, Little Bright Eyes, Little Darling's Birthday Book,* and *Tales from Tennyson,* all published by Raphael Tuck & Sons, also appeared on postcards.

In this section we have not attempted to show complete sets of postcards by Brundage. We have selected a variety of cards from many different sets. They include many that are signed and, in addition, some unsigned postcards that were possibly illustrated by Brundage.

Unsigned miscellaneous greeting postcard. ($10-15)

Signed New Year's postcard, Samuel Gabriel, series 302. ($8-12)

Unsigned New Year's "hold-to-light" postcard. ($40-50)

Unsigned, embossed, 1908, New Year's postcard. ($15-20)

Signed, embossed, 1910, New Year's postcard, series 300, Samuel Gabriel & Sons. ($10-15)

Signed, embossed, New Year's postcards, series 1301, Samuel Gabriel & Sons. ($10-15)

Gladness and buoyant hopes,
And songs that cheer,
Await to meet you
In the glad New Year.

JANUARY 1

Joy be ever with you
Friends be always near,
Hope and peace be present
The New Year way to cheer.

JANUARY 1

"Taking time by the Forelock!"
A Happy New Year to you.

JANUARY 1

Greeting this New Year-day!
May joy with you abide,
And while the good time lingers,
No single care betide.

JANUARY 1

86

Signed, embossed, New Year's postcards, series 300, Samuel Gabriel & Sons. ($10-15)

HAPPY NEW YEAR.

HAPPY NEW YEAR.

HAPPY NEW YEAR.

87

Left:
Unsigned valentine postcard, series 109, Raphael Tuck & Sons. ($20-30)

Unsigned valentine postcard, series 109, Raphael Tuck & Sons. ($20-30)

Unsigned valentine postcard, series 111, Raphael Tuck & Sons. ($20-30)

Unsigned valentine postcard, series 109, Raphael Tuck & Sons. ($20-30)

Unsigned valentine postcard, series 113, Raphael Tuck & Sons. ($20-30)

Above two: Unsigned valentine postcards. ($10-15)

Unsigned valentine postcard, series 109, Raphael Tuck & Sons. ($20-30)

89

Unsigned valentine postcards, series 101, by Raphael Tuck & Sons. ($25-35)

Unsigned, embossed, valentine postcards. ($15-25)

90

Unsigned valentine postcard, "Little Treasures," series 124, Raphael Tuck & Sons. ($25-50)

Unsigned valentine postcard. ($25-50)

Unsigned valentine postcard, "Little Treasures," series 124, Raphael Tuck & Sons. ($25-50)

Unsigned, embossed, St. Patrick's Day postcard, series 106, Raphael Tuck & Sons. ($8-12)

St. Patrick's Day

Shure, it's Meself that Wishes Yez Ivery Blessin'.

St. Patrick's Day

It's Niver too High for the Loikes of Us.

St. Patrick's Day

The Top o' the Mornin' to Ye!

St. Patrick's Day

Good Luck to Yez!

92

Unsigned Easter postcard, series 1040, Raphael Tuck & Sons. ($10-15)

Unsigned, embossed, Easter postcard. ($15-20)

Above and left:
Signed Easter postcards, series 102, Raphael Tuck & Sons. ($20-30)

93

Unsigned, embossed, Decoration Day postcards, series 150, Samuel Gabriel & Sons. ($15-20)

"Brave minds, howe'er at war, are secret friends, Their generous discord with the battle ends."

Peace

"From every mountain side Let Freedom ring!"

"How sleep the brave, who sink to rest, By all their country's wishes blest!"

94

Unsigned, embossed, Decoration Day postcards, series 173, Raphael Tuck & Sons. ($15-20)

"Strew the fair garlands
Where slumber the dead."

"For him that died for his country,
Glory and endless years."

95

Signed, embossed, 1910, Halloween postcards, series 120, Samuel Gabriel & Sons. ($20-30)

Unsigned, embossed, Halloween postcard, series 174, Raphael Tuck & Sons. ($20-30)

96

These four cards are signed, embossed, Halloween postcards, series 123, Samuel Gabriel & Sons. ($15-20)

97

Signed, embossed, Halloween postcards, series 120, Samuel Gabriel & Sons. ($20-30)

Signed, embossed, Thanksgiving postcard series 130, Samuel Gabriel & Sons. ($10-15)

99

Above two photos:
Signed, embossed, Thanksgiving postcards, series 132, Samuel Gabriel & Sons. ($10-15)

100

Signed Christmas postcard, "Ever Welcome, Series 4," Raphael Tuck & Sons. ($25-50)

101

Unsigned New Year's postcard. ($10-15)

Below:
Three unsigned Christmas postcards. ($10-15)

102

Signed, embossed, 1912, Christmas postcards, series 208, Samuel Gabriel & Sons. ($15-20)

Signed Christmas postcards, series 200, copyright 1910, Samuel Gabriel & Sons. ($10-15)

Unsigned, embossed, Christmas postcard, copyright by H. I. Robbins, Boston, 1906. ($20-30)

Unsigned, embossed, Christmas postcard, "Santa Claus Scroll, Series 525", Raphael Tuck & Sons. ($15-25)

Signed, embossed, 1910, Christmas postcard, series 200, Samuel Gabriel & Sons. ($20-30)

Signed, embossed, Christmas postcard, series 200, Samuel Gabriel & Sons. ($20-30)

An unsigned miscellaneous greeting postcard. ($20-30)

A signed miscellaneous greeting postcard "Little Sunbeam, Series 567," Raphael Tuck & Sons. ($25-35)

106

Chapter Five
Cloth and Paper Dolls

Cloth and paper dolls have become a favorite of many collectors and Frances Brundage created many during her career. Most paper dolls are unsigned and we attribute them to Brundage by their style and the publisher.

Many collectors believe that several of the unsigned paper dolls published by Raphael Tuck, some of which are included here, were done by Frances Brundage, since she worked for Raphael Tuck during the time the paper dolls were printed. The "Bridal Party Series" shown on the next page is an example.

For this chapter, we have selected a beautiful group of paper and cloth dolls that we believe were most certainly illustrated by Frances Brundage.

Cut, incomplete, unsigned paper doll set. Same dolls but larger are in the paper doll book *Cuddly Dolls* published by Charles E. Graham & Co. ($50-75)

"The Bridal Party," a series of unsigned paper dolls shown in their wedding attire published by Raphael Tuck & Sons. The dolls are four individually boxed die-cut dolls with 4 costumes and 4 hats each. ($1200-1600 : 4 sets)

Bride and trousseau from "The Bridal Party" paper dolls published by Raphael Tuck & Sons. ($300-400)

Groom and clothes from "The Bridal Party" paper dolls published by Raphael Tuck & Sons. ($300-400)

An uncut signed cloth doll, dated 1916, titled "Dolly Dear." (36 1/4" x 23") ($300-400)

"Dolly Dear # 1," an unsigned paper doll by Samuel Gabriel & Sons. (14") ($150-200)

"Dolly Darling # 3," an unsigned paper doll by Samuel Gabriel & Sons. (Incomplete set - hats missing) (14") ($100-150)

"Dolly Delight # 2," an unsigned paper doll published by Samuel Gabriel & Sons. (Incomplete set—hats missing) (14") ($100-150)

Cover of a signed paper doll book published by Saalfield. (9" x 12") ($50-75)

Cover of an unsigned paper doll book published by Saalfield. (8 1/2" x 12 1/4") ($50-75)

Below and below right:
Die-cut "scrap" paper dolls. Child was to construct the body. (Doll's head and collar—6 1/4" x 7") ($75-100)

110

These paper dolls were originally done for "Children of Many Lands," Raphael Tuck & Sons. The envelope gave credit to Frances Brundage as the designer. Since these were hand-cut, they could be from Father Tuck's Doll Sheets by Raphael Tuck & Sons. They were also reproduced later by McLoughlin Brothers.

Series No. 1. Paper doll published by Raphael Tuck & Sons. Costumes represent Wales, Ireland, Scotland, and England. (8 3/4") ($25-50)

Series No. 3. Paper doll published by Raphael Tuck & Sons. Costumes represent Alsace, Holland, Canada, and Germany. (8 3/4") ($25-50)

Series No. 2. Paper doll published by Raphael Tuck & Sons. Costumes represent Japan, Italy, American Indian, and Turkey. (9") ($25-50)

Series No. 4. Paper doll published by Raphael Tuck & Sons. Costumes represent Switzerland, Russia, France, and Spain. (8 1/4") (This could be the fourth set but reproduced later.) ($25-50)

An unsigned paper doll. (Restored) (8 1/2" x 18 1/2") ($200-300)

Chapter Six
Prints

These large old prints by Frances Brundage are very collectible and difficult to find. Many of these illustrations are chromolithographs. Their beauty would grace the walls of any room.

Brundage images are often reproduced by publishing companies specializing in greeting cards, prints, and miscellaneous items. Her work can also be seen in many of the current popular books reproducing Victorian art. The value listed under each illustration is for an unframed print in good condition.

A signed illustration. (5 1/2" x 7 1/2") ($15-25)

FLOWER GIRLS.

This chromolithograph is a signed, 1900, image by Koemer & Hayes. (11" x 15") ($150-200)

A signed chromolithograph.
(10" x 12") ($100-150)

An unsigned chromolithograph. This image was painted on a plate shown later in book. (11 3/4" x 14") ($200-300)

An unsigned chromolithograph.
(15" x 19") ($275-350)

These signed illustrations are from a set of four that is a favorite of many Brundage collectors. These images are also found in the book *Four Little Rosebuds*. (9 1/2" x 6 1/4") ($75-100)

Prince Florizel and Perdita from "Winter's Tale," a signed illustration. (11 3/4" x 14 3/4") ($75-125)

"Romeo and Juliet," a signed illustration. (9" x 14"—trimmed) ($75-125)

115

"Olivia and Malvolio" from "Twelfth Night," a signed illustration by W. & F. Brundage. (10" x 14" trimmed) ($75-125)

"Titania and the Clown" A signed illustration from "Midsummer Night's Dream." (11 3/4" x 14 3/4") ($75-125)

"Rosalind, Celia and Orlando," a signed illustration by Will and Frances Brundage. (11 1/2" x 13 3/4" — trimmed) ($75-125)

"Petruchio and Katharina," a signed illustration from "Taming of the Shrew" (11 3/4" x 14 3/4") ($75-125)

Three signed illustrations. (6 1/4" x 8 1/4") ($75-125)

AFTER THE BATH.

HAPPY BOY.

DOTTY DIMPLE.

MY BABY.

A signed illustration. This image was also a trade card for John Hancock Mutual Life Insurance Co. (6 1/4" x 8 1/4") ($75-125)

A signed illustration. (6 1/4" x 8 1/4") ($75-125)

117

"Our Father which art in Heaven," a signed chromolithograph. (13 1/2" x 18") ($125-150)

"Now I lay me down to sleep," a signed chromolithograph. (13 1/2" x 18") ($125-150)

"Baby's First Prayer," a signed chromolithograph. (13 3/4" x 18 1/2") ($125-150)

"Baby's First Kiss," a signed chromolithograph. (13 3/4" x 18 1/2") ($125-150)

"Little Boy Blue," a signed chromolithograph. (14 1/2" x 19 1/2") ($150-200)

An unsigned chromolithograph. (13" x 19") ($300-325)

An unsigned illustration. This image was also on a Raphael Tuck Christmas postcard. (16" x 20") ($50-75)

120

A signed illustration. (9 1/2" x 11 1/2") ($75-100)

A signed illustration. (9 1/2" x 10") ($100-150)

A signed, 1900, chromolithograph published by Koemer & Hayes. (11" x 15") ($150-200)

"New Century Girl," a signed, 1900, illustration. (10" x 12 1/2") ($50-75)

121

"Children of the Century — 1830," a signed, 1900, illustration. (10" x 13") ($50-75)

Two signed illustrations. (10 1/2" x 13 1/2") ($100-200)

An unsigned chromolithograph. (11 1/4" x 14 3/4") ($200-300)

122

Chasing the Butterfly.

The Bow in the Sky.

A signed illustration by W. & F. Brundage.
(7" x 9 1/2") ($25-35)

A signed illustration by W. & F. Brundage.
(7 1/4" x 9 1/2") ($25-35)

A signed illustration by W. & F. Brundage.
(6 3/4" x 9") ($25-35)

An unsigned chromolithograph. (trimmed)
(13" x 15 1/2") ($100-200)

A signed chromolithograph.
(20" x 15") ($150-200)

Two signed prints. (11" x 14") ($75-100)

An unsigned chromolithograph.
(15" x 19") ($300-350)

124

Two signed prints published by Raphael Tuck. (11" x 14") ($75-100)

A signed chromolithograph. (9 1/2" x 15") ($100-125)

Two unsigned chromolithographs. (13" x 19") ($50-100)

A signed illustration.
(10" x 13") ($50-75)

"A Child of the Period," a signed, 1900, illustration published by Hays Pub. Co. (10" x 13") ($50-75)

An unsigned chromolithograph. This is also a signed postcard. (10" x 14") ($200-300)

An unsigned chromolithograph. (15" x 19") ($300-350)

An unsigned chromolithograph. This is also a signed postcard. (15" x 19") ($300-350)

Chapter Seven
Miscellaneous

Frances Brundage's work has appeared in many forms and on many items. This section includes die-cuts, Christmas ornaments, flue covers, album covers, a painted plate, jewelry box covers, Christmas booklets, Christmas cards, a large advertisement, marionettes, and bookmarkers. Although most are unsigned, we believe all of this work was done by Frances Brundage.

"Reward of Merit," unsigned card published by Gibson & Co. These cards were for recognition of achievement and attendance. This illustration is signed in a book *Hours In Many Lands* and is a signed, 1896, calendar print from "Children from Many Lands." (6 1/2" x 9") ($35-50)

"Marionette," a paper toy published by Raphael Tuck. (7 1/2" x 11") ($200-400)

SEASONS' GREETINGS
C. M. CALLENDER
Dry Goods, Furnishings and Shoes
EDGERTON, OHIO

Two unsigned embossed die-cuts.

(10" x 19 3/4")
($300-400)

(10" x 15")
($200-300)

129

More unsigned embossed die-cuts.

An unsigned, embossed, die-cut, ribbon Christmas ornament. (4" x 15") ($100-150)

(3 1/2" x 5 1/4") ($20-30)

(7" x 9 1/4") ($50-75)

(6" x 11 1/4") ($100-200)

130

(3" x 6") ($25-50)

(4" x 10") ($75-100)

(7" x 9 1/4") ($50-75)

(3" x 6") ($25-50)

131

An unsigned embossed die-cut. (8" x 8 1/2") ($100-150)

An unsigned, embossed, advertising die-cut. A salesman's reminder of an appointment to show samples for the business of Ivan Frank & Co. (7" x 9 1/2") ($100-150)

Two unsigned flue covers. These were decorative covers for stove vents when the stoves were removed during the summer months. (9 1/2") ($150-200)

An embossed die-cut. This could have been a complimentary gift from a business or a salesman's sample for a calendar. (10" x 13") ($125-200)

A signed celluloid cover of a photograph album. (8 1/2" x 10 3/4" x 1 3/4") ($75-125)

133

An unsigned celluloid cover of a photograph album. (8 1/2" x 11" x 1 1/2") ($75-100)

An unsigned painted plate. A chromolithograph of this image was shown earlier. (7 1/2") ($50-75)

Detail of plate.

(8 1/2" x 5" x 3")
($75-100)

Left and below:
Unsigned covers of jewelry boxes.

(9 1/4" x 6 1/2" x 3 1/4") ($75-100)

Three Unsigned Christmas booklets, with applied cloth pieces, Raphael Tuck & Sons. (4" x 6") ($25-35)

135

Two unsigned die-cut Christmas cards.

(5 1/4" x 6 1/4") ($15-35)

(5 3/4" x 4 1/4") ($25-35)

Two unsigned bookmarkers.
(3 1/4" x 9 3/4") ($25-35)

A signed large print advertisement for Wood, Stubbs & Co. This image was also on a book entitled *Our Darling's Picture Book*. (9 1/2" x 13 1/2") ($200-250)

An unsigned, embossed, die-cut, hanging ornament. (Restored) (4 1/2" x 5") ($25-50)

An unsigned, embossed, die-cut, hanging ornament. This image was also on a calendar shown in next chapter. (Restored) (3 1/4" x 5 1/2") ($25-50)

An embossed die-cut. (Restored) (16 1/2" x 11 1/2") ($300-400)

An unsigned, embossed, die-cut, hanging ornament. (6 1/2" x 9") ($100-150)

An unsigned advertising print.
(10" x 10") ($150-200)

It's very nice to be a dog;
No work, no studying to do;
But doggies can't chew "KIS-ME" Gum,
And, oh! It is such fun to chew.

Kis-Me Gum Co.
Louisville, Ky.

Unsigned advertisements for Kis-Me Gum Co., Louisville, Ky. (5 3/4" x 8") ($50-75)

There is no fruit in all the world,
Not peach or grape or plum,
That yields a flavor half so sweet
As "KIS-ME" Chewing Gum.

Kis-Me Gum Co.
Louisville, Ky.

Flowers! Come see all the flowers I have gathered,
Culled them from woodland and culled them from dale;
Some glowing crimson and wet with the dew-drops,
Some 'mid their green leaves so tender and pale.

What is as fair as a stately white lily?
What half as sweet as a rosebud half blown?
One thing alone can compare with my flowers,
, "KIS-ME" Gum, flowers of confections alone.

Kis-Me Gum Co.
Louisville, Ky.

An unsigned embossed print. This could have been a complimentary business gift or a salesman's sample. (8 1/4" x 12 1/4") ($100-150)

An unsigned embossed die-cut. (7 3/4" x 11") ($100-150)

Chapter Eight
Calendars

These calendar images represent some of the best of the numerous calendars illustrated by Frances Brundage. Most of the calendars were printed for advertisements and complimentary gifts for businesses to give to their customers. The illustrations from the Fairbank's Fairy Calendar of 1900, shown in the complete set on this page and the following pages, are strikingly beautiful examples.

Some book illustrations were also used in calendar form. Two images from *Childhood*, published by Charles E. Graham & Co., can be seen on the Merry Childhood Calendar of 1900, and two more images appear in the 1901 Children's Year Calendar.

The fans are the most expensive of the calendars and the most difficult to find because of the many antique fan collectors who are eager to add them to their collections. Some of the large beautiful die-cut calendars can command a price comparable to the fans.

"Navy Admiral," an unsigned chromolithograph. This image and the following five form a complete 1900 Fairbank's Fairy Calendar published by Gray Lithographic Co., copyright 1899, for N. K. Fairbank Co., Chicago; advertising Fairy Soap. (10" x 12 1/4") ($100-125)

An unsigned, embossed, die-cut calendar for N. B. Robinson, Williamston, Vt. (6 1/2" x 10 1/4") ($75-100)

143

"Artillery Officer," an unsigned chromolithograph from a 1900 Fairbank's Fairy Calendar published by Gray Lithographic Co. (10" x 12 1/4") ($100-125)

"Cavalry Rough Rider," an unsigned chromolithograph from a 1900 Fairbank's Fairy Calendar published by Gray Lithographic Co. (10" x 12 1/4") ($100-125)

144

"Navy Crewman," an unsigned chromolithograph from a 1900 Fairbank's Fairy Calendar published by Gray Lithographic Co. (10" x 12 1/4") ($100-125)

"Infantry Officer," an unsigned chromolithograph from a 1900 Fairbank's Fairy Calendar published by Gray Lithographic Co. (10" x 12 1/4") ($100-125)

145

An unsigned chromolithograph from a 1900 Fairbank's Fairy Calendar published by Gray Lithographic Co. This image completes the calendar, however, this particular calendar page is from a different set of calendar prints for the same company. (10" x 12 1/4") ($100-125)

An unsigned, embossed, 1906, die-cut calendar for Buell Hardware, Leroy, N.Y. (5 3/4" x 9 1/2") ($100-125)

An unsigned, embossed, 1899, die-cut calendar for Snoqualmie Pharmacy, Seattle. (7" x 10") ($100-125)

146

An unsigned, embossed, 1906, die-cut calendar for Geo. L. Chussler Bakery & Confectionery, Chicago. (Restored) (11" x 17 1/2") ($150-200)

"Mother's Darlings," signed calendar. (1 of 4 parts) (8 1/2" x 11 1/2") ($100-125)

An unsigned, embossed, die-cut calendar for L. D. Hendry General Merchandise, Frazee, Minn. (6 3/4" x 11 1/2") ($75-125)

A signed calendar for Peebles Fine Candies, Cincinnati. (6 1/4" x 9 1/2") ($50-75)

"Little Salem Witch," this illustration and the following five are from a signed, 1900, calendar, published by Sprague, Warner & Co., Chicago. (10 1/2" x 12 1/2") ($75-100)

"A Young Puritan." (10 1/2" x 12 1/2") ($75-100)

148

"Priscilla." (10 1/2" x 12 1/2") ($75-100 each)

"A Fair Virginian." (10 1/2" x 12 1/2") ($75-100 each)

"A Knickerbocker Maid." (10 1/2" x 12 1/2") ($75-100 each)

"The Governer's Daughter." (10 1/2" x 12 1/2") ($75-100 each)

An unsigned, embossed, die-cut calendar.
(17" x 12") ($300-400)

An unsigned, embossed, die-cut calendar for A. B. Symes, Rolfe, Iowa. (15 1/2" x 11 1/2") ($250-350)

An unsigned, embossed, die-cut, 1907 calendar. (17 1/4" x 11 1/2") ($300-400)

The following six images form a complete calendar. However, two of the illustrations are from the calendar set advertising "The Paris" and four are from the calendar set advertising F. D. Seward Confectionery.

Four signed, 1899, calendar prints for F. D. Seward Confectionery Co., St. Louis. (10" x 12 3/4") ($75-100)

Two signed, 1899, calendar prints for "The Paris," New York. (10" x 12 3/4") ($75-100)

An unsigned, die-cut, 1901, calendar fan. (11" x 6") ($300-500)

153

An unsigned, die-cut, 1903, calendar fan. (16 1/2" x 9 1/2") ($300-500)

An unsigned, die-cut, 1901, calendar fan. (14 3/4" x 8 1/2") ($300-500)

An unsigned, die-cut, 1900, calendar fan. (10 1/2" x 6 1/4") ($300-500)

155

These prints are a set of six signed illustrations from the 1904 "Sunbeams of the Year" calendar. (9 1/2" x 14") (Set: $400-600)

Sunbeams of the Year

Calendar for 1904

Blest are children, springing fair of face
Like gentle blossoms in the dwelling place.
— Robert Buchanan

Have good-will
To all that lives,
. so that your lives be made
Like soft airs passing by.
— Sir Edwin Arnold

You flit as blithely as bird on wing;
And when you answer, and when they sing,
I know not if they, or You, be Spring.
— Alfred Austin

Oh the flow'rets, the bonnie wee flow'rets,
Glinting, and smiling, and peeping through the grass!
And oh the children, the bonnie little children,
I see them, and love them, and bless them as I pass!
— Charles Mackay

Unsigned die-cut calendar for A. M. Bellack & Son, Columbus, Winconsin. (9 3/4" x 16 3/4") ($150-175)

A signed, embossed, die-cut, 1904, fold-out calendar. (12 3/4" x 13 3/4") ($200-300)

157

An unsigned, embossed, die-cut, fold-out three-dimensional signed calendar. (1 of 6) (9 1/4" x 6 3/4") ($75-125)

Two unsigned calendar prints published by E. P. Dutton & Co., New York. (2 of 12) (9" x 11") ($75-100)

A signed, 1900, calendar "Joyous Life." (1 of 4) (5" x 10") ($50-75)

An unsigned, 1897, calendar for Grand Union Tea Co. (1 of 4) (8" x 12") ($50-75)

An unsigned, embossed, die-cut, 1904, fold-out three-dimensional calendar. (Elfin Queen is missing) (12" x 8 1/2") ($100-125)

159

These six, signed, 1900, calendar prints are from the set "Little Sweethearts." They were published by the Gray Lithography Co., N.Y. exclusively for Frank Leslie's *Popular Monthly* magazine.

An unsigned, embossed, 1904, die-cut calendar. (6" x 11") ($100-125)

An unsigned, embossed, 1902, die-cut calendar. (7 1/2" x 13") ($100-125)

161

These four, unsigned, 1907, calendar prints are chromolithographs with embossed borders. The set is entitled "Smiling Youth." (5 1/4" x 11 1/2") (set - $150-200)

An unsigned, embossed, 1903, die-cut calendar for E. F. Merrill, Woodstock, Vt. (13 1/4" x 10") ($100-125)

A salesman's copy of a 1916, unsigned calendar published by Hayes Lithography, Co., Buffalo, N.Y. (15" x 22 1/2") ($100-150)

163

Two advertising calendars for Peebles Candies, Cincinnati. (6 1/4" x 9 1/2") ($50-75)

An embossed, die-cut, 1915, calendar advertising Jos. Andres & Co., Peru, Indiana. (Same image previously shown on a calendar and a hanging ornament.) (10" x 13 1/2") ($150-200)

164

An embossed, die-cut calendar advertising The New Idea Shoe Co., Manchester, N. H. (The two children on the right were shown on a calendar earlier.) (11 1/2" x 11 3/4") ($150-200)

An unsigned, embossed, die-cut calendar. (11 1/2" x 13 1/2") ($150-200)

165

Above: "Little Darlings," an embossed, die-cut, 1902 calendar for L. Schwarz, New York. (15 1/4" x 10 1/4") ($300-400)

Below: A signed, die-cut calendar, copyright 1895, by Frederick A. Stokes Company. (15" x 9 1/2") ($300-500)

Book List

Title	Publisher	Illustrations	Date	Size	Price
ADVENTURES OF A BROWNIE THE.	Saalfield	Color dust jacket, 1 color, plus black and white. Signed. Book credits.	1927,	5 1/2" X 7 3/4"	$15-20
ADVENTURES OF JACK.	Stecher Litho.	Color cover plus 8 color. Signed. Book credits.	1921	7 1/2" X 13 3/4"	25-35
ALICE'S ADVENTURES IN WONDERLAND	Saalfield	1 color plus black and white. Unsigned. No book credits.		6 3/4" X 9"	10-15
ALL ABOARD FOR STORYLAND	Saalfield	Black and white. Unsigned. No book credits.	1937	7 3/4" X 10"	18-20
ANDERSON'S FAIRY TALES	Saalfield	Color cover plus black and white. Signed. Book credits.	1925	6" X 8 1/2"	8-10
ARABIAN NIGHTS	Saalfield	Color dust jacket, 1 color, plus black and white. Unsigned. Book credits.	1924	6 3/4" X 9"	8-10
ARABIAN NIGHTS, THE (Book I)	Raphael Tuck	Contents unknown. Book credits.		7 1/2" X 9 3/4"	
ARABIAN NIGHTS. THE (Book II)	Raphael Tuck	Contents unknown. Book credits.		7 1/2" X 9 3/4"	
ARABIAN NIGHTS, THE (Complete Edition)	Raphael Tuck	12 color. Book credits. Unseen.		7 1/2" X 10"	
AT THE BACK OF THE NORTH WIND	Saalfield	1 color plus black and white. Unsigned. Book credits.	1927	5" X 7 1/2"	10-15
AT THE PORTAL (A Longfellow Birthday Book)	De Wolfe, Fiske & Co.	12 color. Unsigned. No book credits.	1904	4 1/2" X 5 3/4"	25-50
BABY'S BIOGRAPHY, THE	Brentano's	5 color plus half-tone. Signed. Book credits.	1891	8 3/4" X 10 1/4"	25-50
BABY'S BOOK	Raphael Tuck	4 color. Signed. Book credits.		7 1/2" X 9 3/4"	50-75
BARREN FIG TREE, THE	Raphael Tuck	Color cover only. Signed. No book credits.	1901	9 1/2" X 8"	8-10
BEAUTIFUL ANIMALS	Charles E. Graham	4 color. Signed. No book credits.		10 1/2" X 12"	10-12
BEAUTIFUL STORIES ABOUT CHILDREN	W. E. Scull	4 color, half-tone, plus black and white. Signed. No book credits.	1898	7 1/4" X 9 3/4"	25-50
BEDTIME STORY BOOK	Saalfield	Black and white. Unsigned. No book credits.		8 1/2" X 10 3/4"	18-20
BETTY AND HER CHUMS	Saalfield	Black and white. Signed. No book credits.	1927	7 3/4" X 5 3/4"	6-8
BETTY'S ATTIC THEATRE	Saalfield	Black and white. Signed. No book credits.	1927	7 3/4" X 5 3/4"	6-8
BETTY'S HOLIDAYS	Saalfield	Black and white. Signed. No book credits.	1927	7 3/4" X 5 3/4"	6-8
BILLY WHISKERS AND THE RADIO	Saalfield	6 color plus black and white. Signed. Book credits.	1927	7 1/2" X 9 1/4"	10-15
BILLY WHISKERS AT HOME	Saalfield	Contents unknown. Book credits.	1924		
BILLY WHISKERS IN MISCHIEF	Saalfield	6 color plus black and white. Signed. Book credits.	1926	7 1/2" X 9 1/2"	10-15
BILLY WHISKERS' PRANKS	Saalfield	5 color plus black and white. Signed. Book credits.	1925	7 1/2" X 9 1/2"	10-15
BILLY WHISKERS' TREASURE HUNT	Saalfield	Color cover, 1 color, plus black and white. Unsigned. Book credits.	1928	6 1/4" X 7 3/4" (7 1/2" X 9 1/2")	10-15
BLACK ARROW, THE	Saalfield	Color cover and dust jacket. Unsigned. Book credits.	1926	5" X 7 1/2"	10-15
BLACK BEAUTY	Saalfield	Color cover plus black and white. Unsigned. Book credits.	1922	7 1/2" X 9 1/2"	6-8
BLACK BEAUTY AND OTHER STORIES	Saalfield	Contents unknown. Book credits.	1930		

Title	Publisher	Illustrations	Date	Size	Price
BLIND TOY MAKER, THE	Raphael Tuck	1 color plus black and white. Unsigned. Book credits.		4 1/2" X 6 1/2"	10-15
BOYS AND GIRLS FROM A-Z	Saalfield	Color cover plus 27 color. Signed. Book credits.	1918	9" X 11"	100-125
BOYS AND GIRLS FROM AROUND THE COUNTRY		Contents unknown.			
BRIAR ROSE	Saalfield	Color plus black and white. Unsigned. No book credits.	1939	7 1/2" X 9 3/4"	10-15
CAT'S PAJAMAS, THE	Stecher Litho.	Color. Signed. Book credits.	1932	10 1/4" X 10 1/4"	10-12
CHARACTER SKETCHES (Postcard Painting Book)	Raphael Tuck	Color plus black and white. 8 different postcards. Unsigned.		7 1/4" X 5 1/2"	100-150
CHARMING CHILDREN OF DICKEN'S STORIES	Hertel Jenkins	4 color plus half-tone. Signed. No book credits.		7 1/4" X 9 3/4"	15-25
CHILD IDEALS	DeWolfe, Fiske & Co.	Color cover and 4 color. Signed.		6" X 8"	75-125
CHILD LYRICS	DeWolfe-Fiske & Co.	4 color. Signed. No book credits.		6 1/2" X 9 1/2"	50-75
CHILD'S FIRST BOOK	Charles E. Graham	Color front and back cover only. Unsigned. No book credits.		10 1/4" X 12"	75-125
CHILD'S GARDEN OF VERSES, A	Saalfield	Color cover, 1 color, plus black and white. Signed. Book credits.	1924	6 3/4" X 9 1/4"	10-15
CHILDHOOD	Charles E. Graham	Color cover, 5 color, plus black and white. Unsigned. No book credits. Cloth book.		7 1/2" X 10 1/4"	125-150
CHILDREN OF TODAY	Fred A Stokes	12 color. Signed. Book credits.	1896	9 1/4" X 11 1/4"	500-800
CHILDREN'S BEST STORY BOOK, THE	Saalfield	1 color. Unsigned. No book credits.	1922	7 1/2" X 9 3/4"	15-20
CHILDREN'S DICKENS, THE	Graham & Matlack	4 color plus black and white. Unsigned. No book credits.		7" x 9 1/4"	25-50
CHILDREN'S GALLERY, THE (Adults)	E. P. Dutton	Two color. Signed. Incomplete. Unseen		6 1/4" X 8 1/4"	
CHILDREN'S GALLERY, THE (Children)	E. P. Dutton	Color cover and 3 color. Signed. (Probably incomplete.) Unseen.		6 1/4" X 8 1/4"	
CHILDREN'S GALLERY, THE (Series No. 3)	E. P. Dutton	8 color. Children with either a rabbit, dog, cat, ducks, bird, or doll. Signed. No book credits.		6 1/4" X 8 1/4"	125-150
CHILDREN'S SHAKESPEARE, THE (1)	Raphael Tuck	Color cover. Contents unknown.		7 1/2" X 9 3/4"	
CHILDREN'S SHAKESPEARE, THE (2)	Raphael Tuck	Color cover. Contents unknown.		7 1/2" X 9 3/4"	
CHILDREN'S STORIES FROM DICKENS	Mershon Co.	5 color plus black and white. Signed. Book credits		5 3/4" X 8 1/4"	10-15
CHILDREN'S STORIES FROM DICKENS	Raphael Tuck	12 color. Signed. Book credits.		7 3/4" X 10 1/4"	50-75
CHRISTMAS CAROL, A	Saalfield	Cover. Signed.	1927	4 3/4" X 7 1/2"	10-15
CHRISTMAS LETTER, THE	Hayes Co.	3 color. Unsigned. Book credits.	1911	7" X 5 1/4"	8-10
CHRISTMAS LETTER, THE	Charles E. Graham	3 color. Unsigned. Book credits.		5" X 9 1/4"	15-20
CHRISTMAS MORNING	Sam'l Gabriel	Color cover only. Unsigned No book credits.	1911	9 1/2" X 5 1/4"	8-10
CINDERELLA	Saalfield	Color cover plus 10 color. Unsigned. Book credits.	1921	8 1/2" X 11 1/4"	25-50
CINDERELLA AND OTHER FAIRY TALES	Raphael Tuck	4 color. Unsigned. No book credits.		7 3/4" X 10 1/4"	25-50
COMPLETE MOTHER GOOSE RHYMES	Saalfield	Cover plus black and white. Unsigned. No book credits.	1932	7 1/2" X 9 3/4"	10-15
COMPLETE MOTHER GOOSE, THE	Saalfield	Color cover plus black and white. Unsigned. No book credits.	1937	8" X 10"	18-20
COMPLETE STORY BOOK, THE	Saalfield	1 color plus black and white. Signed. Book credits.	1937	8" X 10 1/2"	12-15
CORNELLI	Saalfield	Color cover plus black and white. Signed. Book credits.	1926	5 3/4" X 8 1/4"	10-15

Title	Publisher	Illustrations	Date	Size	Price
COTTONTAIL FAMILY, THE	Sam'l Gabriel	Color cover plus 14 color. Signed. No book credits.	1918	10 1/2" X 12"	12-15
CUCKOO CLOCK, THE	Saalfield	Color cover. Signed. No book credits. Contents unknown.	1927	5" X 7 1/2"	
CUPID'S SEASON	Holiday Pub..	4 color. Unsigned. No book credits.		5 1/4" X 6 1/2"	25-50
CYMBELINE	Raphael Tuck	1 color plus black and white. Unsigned. Book credits.		4 1/2" X 6 1/2"	10-15
DAUGHTERS OF COLONIAL DAYS	Boston, DeWolfe & Fiske	4 color. Signed. No book credits.		6 1/2" X 9 1/2"	75-125
DEAR OLD SANTA CLAUS	Charles E. Graham	Color cover, 4 color, plus black and white. Unsigned. No book credits.		10 1/4" X 12 1/4"	125-150
DOG OF FLANDERS, A.	Saalfield	Color dust jacket plus black and white. Signed. Book credits.	1926	5" X 7 1/2"	10-15
EAST O' THE SUN WEST O' THE MOON	Saalfield	Color cover plus black and white. Unsigned. Book credits.		7" X 9"	10-15
EIGHT COUSINS	Saalfield	Color dust jacket plus black and white. Signed. Book credits.	1930	5 1/4" X 7 1/2"	10-15
ELVES AND THE SHOEMAKER, THE	Saalfield	Black and white. Unsigned. No book credits.	1930	7 1/2" X 9 3/4"	8-10
FAIRY TALES FOR EVERY CHILD	Saalfield	Color cover plus black and white. Unsigned. No book credits.	1923	9 1/2" X 7 1/2"	6-8
FAMOUS FAIRY TALES	Saalfield	Color cover plus black and white. Unsigned. No book credits.	1923	7 1/2" X 9 1/2"	6-8
FATHER CHRISTMAS	Raphael Tuck	Color cover, 7 color, plus black and white. Unsigned. No book credits.		7 1/2" X 14 1/2"	75-125
FATHER TUCK'S ANNUAL (5170)	Raphael Tuck	6 color plus black and white. Signed. Book credits.	1903	7 1/2" X 10"	200-300
FATHER TUCK'S ANNUAL (5678)	Raphael Tuck	5 color (out of probably 6) plus black and white. Signed. Book credits.		7 1/2" X 10"	200-300
FATHER TUCK'S NURSERY LESSONS	Raphael Tuck	Color cover. Unsigned. Contents unknown.		7 1/2" X 9 3/4"	
FATHER TUCK'S NURSERY RHYMES	Raphael Tuck	Color cover, color, plus black and white. No book credits. Unsigned. Unseen.		6 1/2" X 8 1/2"	
FORTRESS OF STRENGTH	Raphael Tuck	3 color. Signed. Book credits.		7 3/4" X 10 1/4"	15-25
FOUR LITTLE ROSEBUDS	Raphael Tuck	Color cover plus 4 color. Unsigned. Book credits.		8" X 5 1/2"	250-350
FRIENDS FROM FAIRYLAND	Saalfield	Color cover. Unsigned. No book credits.	1911	7 1/2" X 14"	10-15
FRIENDS ON THE FARM ABC	Sam'l Gabriel	Color cover only. Unsigned. No book credits.	1911	8 1/2" X 10 3/4"	10-15
FROLIC FOR FUN	Saalfield	Color front and back cover and 6 color. Signed. No Book credits.	1918	9 3/4" X 11 3/4"	30-40
FROM THE LAND OF SUNSHINE	Raphael Tuck	Color cover.	1896	7 1/2" X 14 3/4"	75-125
GIANT STORY BOOK, THE	Saalfield	Black and white. Unsigned. No book credits.	1926	9 1/2" X 7 1/2"	8-10
GINGERBREAD BOY, THE	Saalfield	4 color. Signed. No book credits.	1921	5 1/2" X 7 1/2"	10-15
GOLDEN HOUR FAIRY STORIES	Saalfield	Color cover plus black and white. Unsigned. No book credits.	1923	7 3/4" X 9 1/2"	8-10
GOLDEN STORY BOOK	Saalfield	1 color plus black and white. Unsigned. No book credits.	1939	6 3/4" X 9"	12-15
GOLDILOCKS	Saalfield	Color cover plus 17 color. Signed. Book credits.	1919	7 3/4" X 13 3/4"	25-50
GOODNIGHT STORY BOOK	Saalfield	Black and white. Unsigned. No book credits.	1937	7 3/4" X 10"	6-8
GRANNY'S STORIES	Raphael Tuck	Contents unknown. Book credits.			
GRIMM'S FAIRY TALES	Saalfield	Color cover, 1 color, plus black and white. Signed. Book credits.		6 1/4" X 8 1/2"	10-15
HANSEL AND GRETEL	Saalfield	4 color plus black and white. Signed. No book credits.	1921	4 1/2" X 6 1/4"	8-15
HAPPY BOYS AND GIRLS	Saalfield	Color cover, 5 color, plus two-tone. Signed. No book credits.	1918	9 1/2" X 11 1/2"	20-25
HAPPY MOMENTS PAINTING AND DRAWING BOOK	Saalfield	Painting, drawing and coloring book. Color cover, color, plus black and white. Unsigned. No book credits.	1925	10 1/4" X 8"	8-15
HAPPY NURSERY HOURS	Saalfield	Color cover only. Signed. No book credits. Same cover as Famous Fairy Tales.	1920	6 1/4" X 8 1/2"	10-12
HEART OF GOLD	Saalfield	Contents unknown. Book credits.	1915		
HEIDE	Saalfield	4 color plus black and white. Signed. Book credits.	1924	7 1/2" X 9 1/2"	15-20

Title	Publisher	Illustrations	Date	Size	Price
HENNY-PENNY	Saalfield	Color cover plus 4 color. Signed. No book credits.	1921	8 1/2" X 11"	12-15
HOLIDAY STORIES	Holiday Pub.	Color cover plus 6 color. Unsigned. Book credits.	1906	5 1/2" X 7"	45-55
HOURS IN MANY LANDS	Raphael Tuck	12 color. Signed. Book credits.		7 1/2" X 9 3/4"	200-300
IN THE COUNTRY ABC	Sam'l Gabriel	Color cover only. Unsigned. No book credits.	1924	8 3/4" X 11"	15-20
IT'S FUN TO DRAW	Contents unknown.				
JACK AND THE BEANSTALK	Saalfield	10 color plus black and white. Signed. No book credits.		10" X 14"	25-50
JIM DAVIS	Saalfield	Color cover plus black and white. Signed. Book credits.	1926	4 3/4" X 7 1/2"	10-15
JUMBO STORY BOOK, THE	Saalfield	Black and white. Unsigned. No book credits.	1926	9 1/4" X 7 1/4"	8-10
KIDNAPPED	Saalfield	Color dust jacket plus black and white. Signed. Book credits.	1926	5 1/4" X 7 3/4"	10-15
KING ARTHUR FOR BOYS	Saalfield	Color cover. Signed. Book credits.		5" X 7 1/2"	10-15
KING OF THE GOLDEN RIVER, THE	Saalfield	Black and white. Unsigned. Book credits.	1926	6" X 6 3/4"	15-20
KITTY-CAT STORIES	Saalfield	Color cover only. Signed. No book credits.	1930	4 1/2" X 7 1/2"	6-8
LEGEND OF SLEEPY HOLLOW, THE	Saalfield	Black and white. Unsigned. Book credits.	1926	6" X 6 3/4"	10-15
LITTLE AUNT EMMIE	J. B. Lippincott	1 color. Signed. No book credits.	1925	5 1/2" X 8"	8-10
LITTLE BELLES AND BEAUX	Fred A. Stokes	Color cover and 6 color. Signed. Book credits.	1896	9 1/4" X 11 1/4"	300-400
LITTLE BLACK SAMBO	Saalfield	Color cover plus black and white. Unsigned. No book credits.	1939	7 3/4" X 10 3/4"	60-75
LITTLE BO PEEP & OTHER JINGLES	Saalfield	Color cover and color. Unsigned. No book credits.	1919	7" X 9"	12-15
LITTLE BRIGHT EYES	Raphael Tuck	6 color. Signed. Book credits.		7 1/2" X 10"	300-400
LITTLE DARLING'S BIRTHDAY BOOK	Raphael Tuck	12 color. Signed. Book credits.		4" X 5"	125-150
LITTLE DARLING'S LESSON BOOK	Raphael Tuck	Color cover. Unsigned. Contents unknown.		7 1/2" X 9 3/4"	
LITTLE LAME PRINCE, THE	Saalfield	Color cover, color dust jacket, plus black and white. Signed. Book credits.	1924	6 3/4" X 9"	20-25
LITTLE MEN	Saalfield	1 color plus black and white. Signed. Book credits.	1928	6 1/4" X 9"	10-15
LITTLE MEN AND MAIDS	Fred A. Stokes	6 color. Signed. Book credits.	1896	9 1/4" X 11 1/4"	300-400
LITTLE MOTHER GOOSE	Saalfield	Color cover plus 3 color. Unsigned. No book credits.	1915	4 1/2" X 5 1/2"	6-8
LITTLE PAUL DOMBEY	Raphael Tuck	1 color. Signed. Book credits.		4 1/2" X 6 3/4"	6-8
LITTLE QUAKER MEETING, A	Raphael Tuck	Color front and back cover, 6 color, plus black and white. Unsigned. Book credits.		11 1/2" X 7 1/2"	100-150
LITTLE RED RIDING HOOD	Raphael Tuck	Color cover, 6 color plus black and white. No. 1477. Unsigned. No book credits.		8 3/4" X 10 3/4"	25-50
LITTLE RED RIDING HOOD	Stecher Litho.	6 color plus 8 monotone. Signed. No book credits.	1929	9 3/4" X 10 1/2"	20-25
LITTLE RED RIDING HOOD	Saalfield	Color cover only. Signed. No book credits.	1928	7 3/4" X 13 3/4"	20-30
LITTLE SUNBEAMS (Postcard Painting Book)	Raphael Tuck	8 different postcards. Color plus black and white. Signed. Unseen.		7 1/4" X 5 1/2"	
LITTLE SWISS BOY, A	Saalfield	1 color plus black and white. Unsigned. Book credits.	1926	5" X 7 1/2"	10-15
LITTLE TREASURES BIRTHDAY BOOK	Raphael Tuck	12 color. Unsigned. No book credits.		4 1/4" X 5 1/4"	50-75
LITTLE WIDE AWAKE	W. B. Conkey	Color cover, 1 color, plus black and white. Unsigned. No book credits.	1903	6 1/4" X 8 1/2"	10-15
LITTLE WOMEN	Saalfield	Color cover, 1 color, plus black and white. Signed. Book credits.	1926	6 3/4" X 9"	10-15
LITTLE WOODEN SHOES	Saalfield	Color cover plus 4 color. Signed. Book credits.	1921	7 1/2" X 9"	15-25
LOOK UP LIFT UP	Cranston & Curts	4 color. Signed. No book credits.		7 1/2" X 10"	20-25
LOVE	Hayes Litho.	3 color. Signed. No book credits.		4" X 8"	10-12
LOVE HOLDS THE REINS	Raphael Tuck	Color cover plus 1 color. Signed. No book credits.		8 1/4" X 10 1/4"	125-150
LOVE'S GREETINGS	Boston, DeWolfe & Fiske	4 color. Signed. No book credits.		6 1/2" X 9 1/2"	50-75
MAXA'S CHILDREN	Saalfield	Color dust jacket plus black and white. Signed. Book credits.	1926	5 3/4" X 8 1/4"	10-15
MERCHANT OF VENICE, THE	Raphael Tuck	Color cover plus 1 color. Signed. Book credits.		4 1/2" X 6 1/2"	10-15

Title	Publisher	Illustrations	Date	Size	Price
MIDSUMMER NIGHT'S DREAM, A	Raphael Tuck	Color cover plus 1 color. Unsigned. Book credits.		4 1/2" X 6 1/2"	10-15
MONI THE GOAT BOY	Saalfield	Black and white. Unsigned. Book credits.	1926	5 1/4" X 7 3/4"	5-6
MOO COW PAINTING BOOK	Saalfield	Painting, drawing and coloring book. Color plus black and white. Unsigned. No book credits.	1927	10 1/2" X 7"	8-10
MOTHER GOOSE	Saalfield	Color cover plus some black and white. Unsigned. No book credits.	1915	6" X 7 3/4"	10-12
MOTHER GOOSE ABC BOOK	M. A. Donohue	Color. Signed. Two books. One is a pattern book.	1913	9 3/4" X 12"	50-75
MOTHER GOOSE JINGLES	M. A. Donohue	Color cover only. Signed. No book credits.	1913	9 1/2" X 12"	15-20
MOTHER GOOSE NURSERY RHYMES	M. A. Donohue	Color cover only. Signed. No book credits.	1913	9 3/4" X 12"	10-12
MOTHER GOOSE RHYMES	Saalfield	Color cover plus 12 color. Signed. No book credits.		10" X 13 3/4"	25-50
MOTHER'S LITTLE MAN	Saalfield	Color cover only. Unsigned. No book credits.	1928	5 1/4" X 7"	8-10
MOTHER'S LITTLE MAN	Hayes Litho.	Color cover only. Unsigned. No book credits.	1911	5 1/4" X 7"	10-15
MY BUNNY RABBIT	Sam'l Gabriel	1 signed color. Signed. No book credits.	1920	11" X 9 1/4"	12-14
MY FAVORITE GAMES	Saalfield	4 color. Unsigned. No book credits.		5 1/2" X 9"	6-8
MY LITTLE PANSY PEOPLE	Raphael Tuck	Color cover plus 6 color. Unsigned. Book credits.		7 1/2" X 9 3/4"	100-150
MY OWN DOLLY	Saalfield	Color plus black and white. Unsigned. No book credits.	1915	10 1/4" X 14"	12-14
NIGHT BEFORE CHRISTMAS SURPRISE BOOK, THE	Saalfield	Painting, drawing and coloring book. Signed. No book credits.	1921	12" X 8"	18-20
NIGHT BEFORE CHRISTMAS, THE	Saalfield	Color cover plus 12 color. Signed. No book credits.		10" X 14"	25-50
NIGHT BEFORE CHRISTMAS, THE	Charles E. Graham	Color cover, 11 color, plus black and white. Unsigned. No book credits.		10 1/2" X 12 1/2"	125-150
NURNBERG STOVE, THE	Saalfield	1 color. Signed. Book credits.	1927	7 1/2" X 5 3/4"	8-10
NURSERY PETS	Saalfield	Color back cover, 2 color, plus black and white. Unsigned. No book credits.	1918	8 3/4" X 5 3/4"	8-10
NURSERYLAND	Sam'l Gabriel	Color cover. Unsigned. No book credits.	1915	10" X 12"	10-15
OLD FASHIONED GIRL, AN	Saalfield	Color dust jacket plus black and white. Signed. Book credits.	1928	5 1/4" X 7 3/4"	10-15
OLD OLD STORY, THE	Raphael Tuck	Color cover, 6 color, plus sepia by Clausen and Brundage. Unsigned. Book credits.		6 3/4" X 7 1/2"	15-25
ONCE UPON A TIME STORIES	Saalfield	1 color plus black and white. Unsigned. No book credits.	1933	6 3/4" X 9"	12-15
ONCE UPON A TIME TALES	Saalfield	Contents unknown. Book credits.	1930		
OUR BABY (1)	Raphael Tuck	4 color plus black and white. Signed. Book credits. (Blue cover)		5 1/4" X 7 1/2"	100-125
OUR BABY (2)	Raphael Tuck	4 different color plus black and white. Signed. Book credits. (white cover)		5 1/4" X 7 1/2"	100-125
OUR BABY (3)	G. R. Gibson & Co.	Cover and 8 illustrations in yellow, pink and off-white. Unsigned. Book credits.		10" X 7 3/4"	50-75
OUR BABY'S HISTORY	Nister and Dutton	4 color. Signed. No book credits.		6 1/2" X 8"	125-150
OUR DARLING'S PICTURE BOOK	M. A. Donohue	Color cover. Signed.	1913	10" X 13 1/4"	75-100
OUR LITTLE MEN AND MAIDENS	Ernest Nister	12 color. Unsigned. Book credits.		7 1/2" X 9 1/4"	200-300
OUR STORY BOOK	Cupples & Leon Co.	Color cover. Unsigned. No book credits.	1916	8" X 9 3/4"	25-50
OUR WEDDING	Raphael Tuck	8 color. Signed. Book credits.		9" X 12"	300-500
PEACE ON EARTH	Raphael Tuck	Color front cover and small color illus. Book credits. Unsigned.		6 1/2" X 7 1/2"	100-150
PEEK-A-BOO PAINTING AND DRAWING	Saalfield	Painting, drawing and coloring book. Color cover. Unsigned. No book credits.	1915	10" X 5 1/4"	8-10
PEEP AT THE WORLD'S FAIR, A	Raphael Tuck	Color cover. Cover signed by W. & F. Brundage. Book credits. Contents unknown.		7 1/4" X 9 1/2"	

Title	Publisher	Illustrations	Date	Size	Price
PETS FOR COLORING	Saalfield	Painting, drawing, and coloring book. Black and white. Unsigned. No book credits.	1928	7 3/4" X 10 3/4"	8-10
PICTURE PAGES	Raphael Tuck	Contents unknown. Book credits.			
PIED PIPER OF HAMELIN, THE	Saalfield	1 color plus black and white. Signed. Book credits.	1926	5 1/4" X 7 3/4" 6 1/2" X 8"	10-15
PINOCCHIO	Saalfield	Color cover plus black and white. Signed. Book credits.	1924	4 3/4" X 7 1/2"	10-15
PLAY AND LEARN	McLoughlin	Color cover only. Unsigned. No book credits.	1900	10" X 7 3/4"	10-12
PRINCESS AND CURDIE, THE	Saalfield	Color cover plus black and white. Signed. Book credits.	1927	5" X 7 1/2"	10-15
PRINCESS AND THE GOBLIN, THE	Saalfield	Color cover plus black and white. Signed. Book credits.	1927	5" X 7 1/2"	10-15
PUSS IN BOOTS	Saalfield	Color cover plus black and white. Signed. No book credits.	1922	7 1/2" X 9 1/2"	8-10
PUSS IN BOOTS PAINTING AND DRAWING	Saalfield	Painting, drawing and coloring book. Unsigned. No book credits.	1927	10" X 7 3/4"	8-10
PYGMIES, THE	H. M. Caldwell	Color cover only. Unsigned. No book credits.	1909	7 3/4" X 5 3/4"	5-7
QUACK OR TWO FROM ME TO YOU, A	Stecher Litho.	Color cover plus 20 color. Signed. Book credits.	1930	7 3/4" X 13 1/2"	50-75
RAMBLES IN HOLLAND (Postcard Painting Book)	Raphael Tuck	8 different postcards. Color plus black and white. Signed. Book credits.		6" X 7"	100-150
RECITATIONS FOR BOYS AND GIRLS	John C. Winston.	Color cover only. Unsigned. No book credits.	1902	9" X 6 1/2"	8-10
RED NETWORK STORIES FOR CHILDREN	Saalfield	Black and white. Signed. No book credits.	1929	7 1/2" X 9 1/2"	8-10
RED RIDING HOOD & OTHER STORIES	Unknown	Color cover, color, plus black and white. Unsigned. No book credits.		6 1/4" X 8"	10-15
RHYMES FOR BABY	Saalfield	8 color. Unsigned. No book credits.	1918	6" X 6 1/2"	6-8
RIP VAN WINKLE	Saalfield	Color cover plus black and white. Signed. Book credits.	1927	6 3/4" X 8"	10-15
ROBIN HOOD	Saalfield	Color cover plus black and white. Unsigned. Book credits.		5" X 7 1/2"	10-15
ROBINSON CRUSOE	Saalfield	Color cover plus black and white. Unsigned. Book credits.		5" X 7 1/2"	10-15
ROMEO AND JULIET	Raphael Tuck	1 color plus black and white. Unsigned. Book credits.		4 1/2" X 6 1/2"	10-15
ROYAL CHILDREN OF ENGLISH HISTORY	Raphael Tuck	10 color. Signed. Book credits.		7 3/4" X 10 1/4"	25-50
ROYAL CHILDREN OF ENGLISH HISTORY	The Mershon Company	5 color. Signed. Book credits.		5 1/2" X 8"	15-20
ROYAL CHILDREN OF ENGLISH HISTORY (Book 2)	Raphael Tuck	Color cover and 2 color. Signed. Book credits.		7 1/2" X 9 3/4"	15-25
RUNAWAY COUPLE, THE	Raphael Tuck	B & W only. Unsigned. Book credits.		4 1/2" X 6 1/2"	8-10
SILVER BELLS AND COCKLE SHELLS	Saalfield	4 color. Unsigned. No book credits.	1919	6 3/4" X 8 1/2"	5-6
SNOW WHITE AND ROSE RED	Stecher Litho.	Color cover, 6 color, plus 8 two-tone. Signed. Book credits.	1917	10" X 10 1/2"	25-50
SNOW WHITE AND ROSE RED	Raphael Tuck	Color cover. Signed. No book credits.	1898	10 1/2" X 8 1/2"	15-20
SOMETHING TO TELL YOU	Raphael Tuck	Color cover. Book credits. Contents unknown.		7 1/2" X 10"	200-300
SOWER, THE	Raphael Tuck	Color cover only. Signed. No book credits.	1901	9 1/2" X 8"	8-10
SPORTS AND PLAYTIMES	Saalfield	Color cover plus color. Signed. No book credits.	1918	11" X 9 1/2"	15-20
STORIES FROM THE ARABIAN NIGHTS	Saalfield	Color cover, 1 color, plus black and white. Signed. Book credits.	1924	6 3/4" X 9"	10-15
STORIES WE LIKE	Saalfield	Black and white. Unsigned. No book credits.	1942	11" X 8 1/2"	6-8
STORY FRIENDS	Saalfield	1 color plus black and white. Unsigned. No book credits.	1933	6 3/4" X 9 1/4"	8-10
STORY HOURS FOR GIRLS AND BOYS	Saalfield	1 color plus black and white. Signed. No book credits.	1933	7" X 9"	10-12
STORY OF COLUMBUS, THE	Raphael Tuck	6 color and 6 half-tone. Signed. Illustrated by William and Frances Brundage. Book credits.	1892	14" X 18"	400-500

Title	Publisher	Illustrations	Date	Size	Price
STORY OF JOSEPH, THE	Raphael Tuck	Color cover only. Unsigned. No book credits.		8 1/2" X 7"	6-8
STORY OF MOSES, THE	Raphael Tuck	Color cover plus black and white. Unsigned. No book credits.		7" X 8 3/4"	10-15
STORY TIME: A COL. OF FAVORITE TALES FOR BOYS & GIRLS	Saalfield	Contents unknown. Book credits.	1930		
STORYLAND	Saalfield	1 color plus black and white. Signed. Book credits.	1932	7 1/2" X 9 3/4"	10-15
SUNSHINE PAINTING AND CRAYONING BOOK	Saalfield	Painting, drawing and coloring book. Color plus black and white. Unsigned. No book credits.	1926	9 1/2" X 12 3/4"	8-10
SWISS FAMILY ROBINSON, THE	Saalfield	1 color plus black and white. Unsigned. Book credits.	1924	5" X 7 1/2"	10-15
TALE OF PETER RABBIT, THE	Saalfield	Color cover only. Signed. No book credits.	1928	11 1/2" X 8"	10-12
TALE OF THE LITTLE BUNNIES, A	Sam'l Gabriel	3 color. Signed. Book credits.	1914	7 1/2" X 14"	12-15
TALE OF THE LITTLE CHICKS, A	Sam'l Gabriel	3 color plus 12 two-tone. Signed. Book credits.	1914	7 1/4" X 14 1/4"	25-50
TALES FROM GRIMM	Saalfield	Color cover plus 1 color. Signed. Book credits.	1924	6 1/2" X 9"	12-15
TALES FROM LONGFELLOW	Raphael Tuck	6 color. Signed. Book credits.		7 1/4" X 9 3/4"	150-175
TALES FROM TENNYSON	Raphael Tuck	5 color plus black and white. Signed. Book credits.		7 1/2" X 10"	125-150
TALES FROM THE ARABIAN NIGHTS	Saalfield	Color cover plus black and white. Signed. Book credits.	1924	9" X 7"	10-15
TAMING OF THE SHREW, THE	Raphael Tuck	1 color plus black and white. Unsigned. Book credits.		4 1/2" X 6 1/2"	10-15
TEN VIRGINS, THE	Raphael Tuck	Color cover only. Signed. No book credits.	1901	9 1/2" X 8"	8-10
THREE BEARS, THE	Saalfield	Color cover plus 8 color. Signed. Book credits.	1926	6" X 8"	12-15
THREE BEARS, THE	Raphael Tuck	Color cover, color, plus black and white. No credits. Unsigned. No book credits. Unseen.		6 1/2" X 8 1/2"	
THREE LITTLE PIGS, THE	Saalfield	Color cover. Signed. No book credits. (2 sizes of books)	1921	7 1/2" X 9 1/2"	12-15
TINY TIM	Raphael Tuck	1 color. Unsigned. Book credits.		4 1/2" X 6 1/2"	10-15
TOWARD THE LIGHT	Raphael Tuck	Color front and back cover plus small print. Unsigned. Book credits.		5" X 9 1/2"	50-75
TREASURE ISLAND	Saalfield	Color cover plus black and white. Signed. Book credits.		5 1/4" X 7 1/2"	10-15
TRUSTY AND TRUE	Sam'l Gabriel	Color front and back covers. Unsigned. No book credits.	1911	7 1/2" X 14 1/2"	20-30
TWILIGHT STORIES	Saalfield	1 color plus black and white. Signed. No book credits.	1939	6 3/4" X 9"	12-15
TWO LITTLE PLAYMATES	M. A. Donohue	Book credits. Contents unknown.	1913	13 1/4" X 10"	
UNCLE TITUS IN THE COUNTRY	Saalfield	Color cover plus black and white. Signed. Book credits.	1926	5 1/4" X 7 1/2"	10-15
WEDDING BELLS	Raphael Tuck	3 color. Signed. Book credits.		5 1/4" X 7 3/4"	125-150
WEE LITTLE ONES	Saalfield	Color cover plus 4 color. Signed. No book credits.	1918	9 1/2" X 11	15-20
WEE PETER PUG	Saalfield	Color cover only. Signed. No book credits.	1928	6 1/4" X 11 1/2"	12-15
WHAT HAPPENED TO TOMMY?	Stecher Lithographic Co.	Color cover, 6 color, plus 8 two-tone. Signed. Book credits.	1921	7 3/4" X 13 1/2" 7 1/2" X 10 1/2"	25-50
WHEN I GROW UP	Sam'l Gabriel	Color front and back cover and 4 color. Book credits. Signed.	1915	8 1/2" X 10 3/4"	30-40
WHO'S THERE?	Raphael Tuck	4 color. Signed. No book credits.	1895	8 3/4" X 10 3/4"	25-50
WHOSE LITTLE BABY ARE YOU?	Sam'l Gabriel	Color cover, 5 color, 14 small monotones, plus black and white. Signed. No book credits.		7 1/2" X 14 1/2"	25-50
WHOSE LITTLE DOG ARE YOU?	Sam'l Gabriel	Color cover plus 4 color. Unsigned. No book credits.	1913	7 1/2" X 14"	18-20
WHOSE LITTLE KITTY ARE YOU?	Sam'l Gabriel	Color front and back covers, 4 color plus two-tones. Signed. No book credits.		7 1/2" X 14 1/2"	35-50
WINTER'S TALE, THE	Raphael Tuck	1 color plus black and white. Unsigned. Book credits.		4 1/2" X 6 1/2"	10-15
WONDERFUL STORY BOOK	Saalfield	Color cover, 1 color, plus black and white. Unsigned. Book credits.	1925	7 3/4" X 9 1/2"	10-12

Bibliography

Budd, Ellen H., and George M., *Frances Brundage Post Cards*, 1990.

Family History Library, Geneology Section, Church of Jesus Christ of Latter Day Saints.

Fiction Folklore, Fantasy & Poetry for Children 1876-1985, R. R. Bowker Co., N. Y., Reed Publishing Co., 1969.

Fielding, Mantle, *Dictionary of American Painters, Sculptors & Engravers*, published by Apollo Books, Lightner Publishing Corp., 1983.

Musser, Cynthia Erfurt (in collaboration with Joyce D. McClelland), *Precious Paper Dolls*, Hobby House Press, Cumberland, Md., 1985.

Nuhn, Roy, "Nursery Rhyme & Fairy Tale Books Still Enchant Collectors," *The Antique Trader Weekly*, March 8, 1995.

Quayle, Eric, *The Collector's Book of Children's Books*, published by Clarkson N. Potter, Inc., New York, 1971.

"Rembrandt Lockwood and Lockwood Family Papers," Archives of American Art, Smithsonian Institution.

Troyer, Fanny G., "Frances Brundage, She Understood Children," for *Hobbies Magazine*, June 1959.

Whitton, Blair, and Margaret, *A Collectors Guide to Raphael Tuck & Sons*, Hobby House Press, Cumberland, Md., 1991

Who Was Who In American Art, Sound View Press, 1985.

Young, William, *A Dictionary of American Artists, Sculptors & Engravers*, William Young & Co., Mass.

Index

Album Covers, 133, 134
Book Markers, 136
Books
 Baby's Book, 37
 Child Lyrics, 22
 Childhood, 28
 Children of Today, 6-9
 Children's Gallery, The, 12, 13
 Children's Stories From Dickens, 29
 Cinderella, 23
 Complete Mother Goose, 24
 Daughters of Colonial Days, 40
 Dear Old Santa Claus, 27
 Father Christmas, 27
 Father Tuck's Annual, 41
 Frolic For Fun, 18
 Goldilocks And The Three Bears, 23
 Hours in Many Lands, 10-12
 Little Bright Eyes, 16, 17
 Little Darling's Birthday Book, 34, 35
 Little Quaker Meeting, A, 32
 Little Red Riding Hood, 23, 25
 Love Holds The Reins, 26
 Love's Greetings, 39
 My Favorite Games, 24
 My Little Pansy People, 25, 32
 Night Before Christmas, The, 27
 Our Baby, 37, 38
 Our Baby's History, 36
 Our Little Men and Maidens, 14, 15
 Our Story Book, 24
 Our Wedding, 33
 Rip Van Winkle, 25
 Royal Children of English History, 30
 Snow-white And Rose-red, 25
 Story of Columbus, The, 31
 Tales From Longfellow, 19, 20
 Tales From Tennyson, 20, 21
 Three Bears, The, 24
 Toward The Light, 6
 Wedding Bells, 10
 When I Grow Up, 40
Calendars: (Titled)
 "Bright Eyes," 154
 "Children's Year, The," 153
 "Elfin Queen, The," 159
 "Fairbanks Fairy," 143-146
 "Glory to God," 157
 "Indian Maidens," 154, 155
 "Joyous Life," 159
 "Little Darlings," 166
 "Little Sweethearts," 160
 "Merry Childhood," 155
 "Merry Hearts," 161
 "Mother's Darlings," 147
 "One Hundred Years Ago," 148, 149
 "Only A Face in the Window," 161
 "Smiling Youth," 162
 "Sunbeams of the Year," 156, 157
Christmas:
 Cards, 135, 136
 Ornament, 130
 Postcards, 101-106
Decoration Day, 94, 95
Easter, 93
Fans:
 Calendars, 153-155
 Valentines, 63-65
Flue Covers, 133
Halloween, 96-98
Jewelry Boxes, 135
Marionette, 128

New Year's, 84-87
Ornaments, Hanging, 130, 138, 139
Paper and Cloth Dolls:
 Gabriel, Samuel, 109
 Graham, Charles E., 107
 Saalfield, 108, 110
 Tuck, Raphael, 107, 108, 111
Plates, Painted, 134
Reward of Merit, 128
Salesman's Samples, 133, 142
St. Patrick's Day, 92
Thanksgiving, 99, 100
Trade Cards: (sets)
 Arbuckle Bros. Coffee, 56
 Everett Piano, 55
 Glenwood Ranges, 48, 49, 54
 Gold Bland Coffee, 52
 Hancock, John, Life Ins., 57
 Home Insurance, 51, 52
 Woolson Spice, 42-46
Valentines:
 Easel, 61-63, 67, 68, 71-73, 78, 81, 83
 Fans, 63-65
 Folding, 61, 67, 68, 77
 Fold-out, 60, 63, 66, 67, 70, 76, 79-82
 Honeycomb, 66, 80
 Mechanical, 58-60, 69, 73, 74
 Parchment, 75
 Postcards, 88-91
 Ribbon, 66, 75, 76